Moon Books
Gods & Goddesses
Colouring Book

First published by Moon Books, 2016
Moon Books is an imprint of John Hunt Publishing Ltd., Laurel House, Station Approach,
Alresford, Hants, SO24 9JH, UK
office1@jhpbooks.net
www.johnhuntpublishing.com
www.moon-books.net

For distributor details and how to order please visit the 'Ordering' section on our website.

Text copyright: Rachel Patterson 2016

ISBN: 978 1 78279 127 0

A CIP catalogue record for this book is available from the British Library.

Design: Stuart Davies

Printed and bound by CPI Group (UK) Ltd, Croydon, CR0 4YY, UK

Moon Books
Gods & Goddesses
Colouring Book

Rachel Patterson

MOON
BOOKS

Winchester, UK
Washington, USA

ARIANRHOD

— Celtic —

Arianrhod's name translates as 'silver wheel or disc'.
The silver wheel represents the turning of the year and time itself.
She is a Celtic star, moon and sea goddess.
She rules Caer Sidi where she guides souls between
incarnations and thus is also a goddess of reincarnation and
her palace is said to be situated in the Aurora Borealis.
Arianrhod can also be called upon for fertility and the weaving of cosmic
time and fate. She is able to shape shift into a large owl
and through it's eyes she sees into the depths of the human soul.
The owl symbolises death, renewal, wisdom, moon magic and initiations.

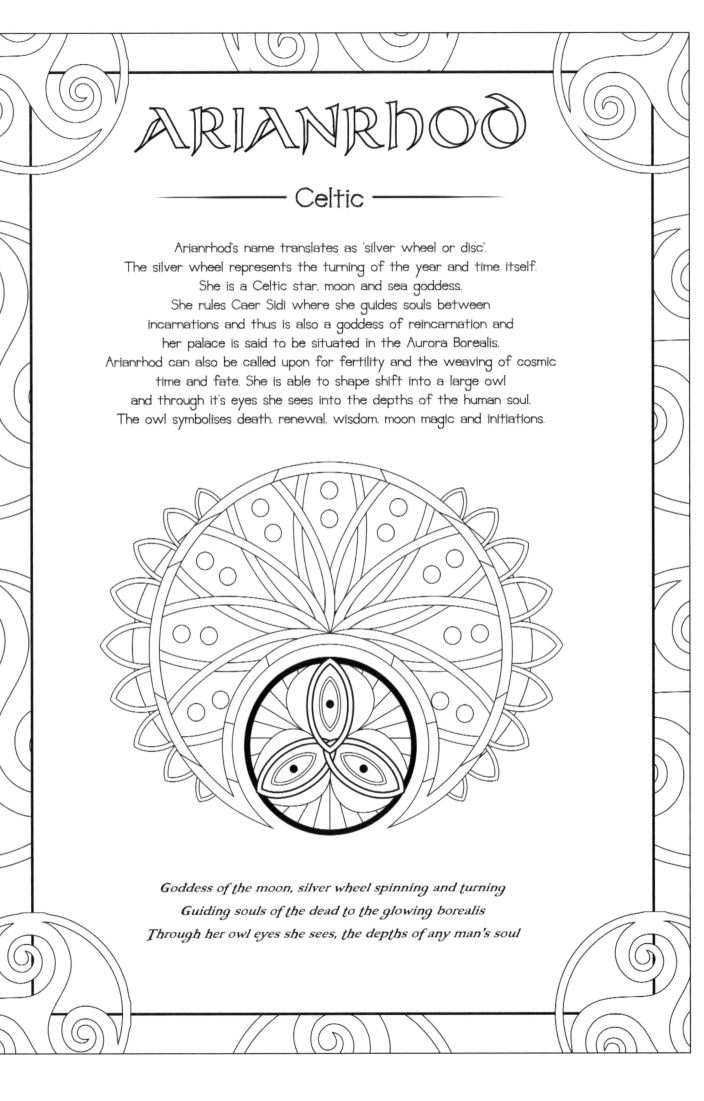

Goddess of the moon, silver wheel spinning and turning

Guiding souls of the dead to the glowing borealis

Through her owl eyes she sees, the depths of any man's soul

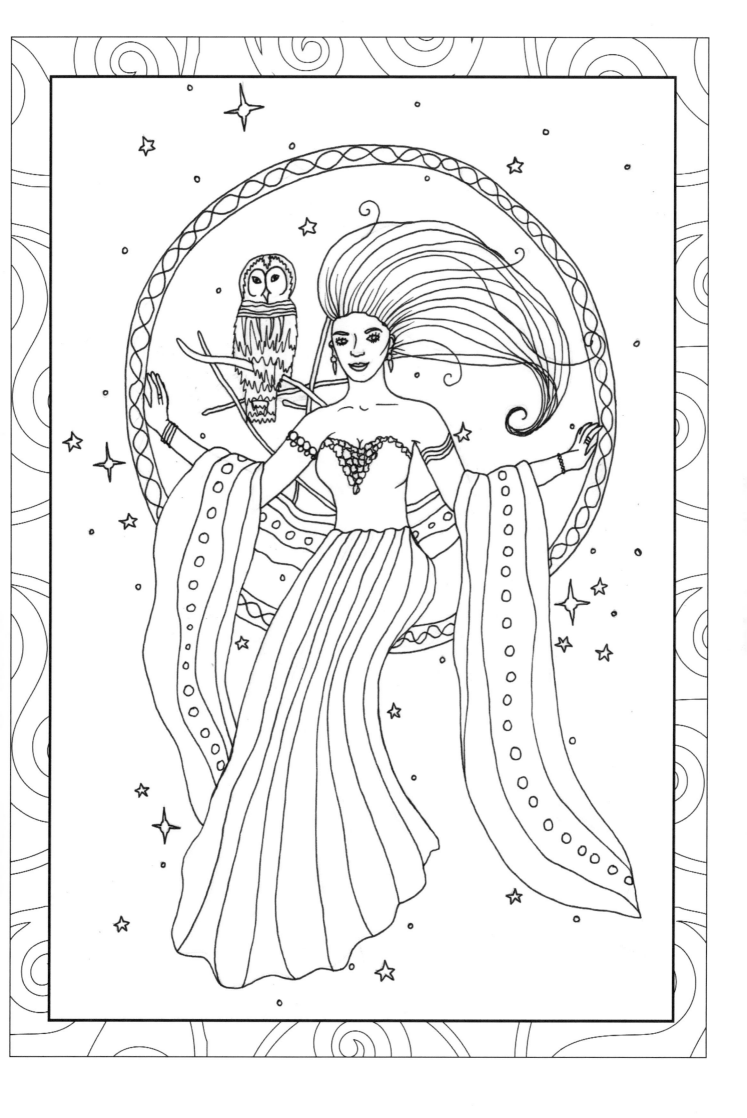

BLODEUWEDD

— Celtic —

This Welsh goddess was created by magicians to be a mate to the god Lleu as a counter measure to a curse that he would never have a wife from any race on the Earth. They made her from nine types of blossom; oak, meadowsweet, broom, cockle, bean, nettle, chestnut, primrose and hawthorn.
However her treacherous behaviour towards Lleu incurred the same magicians to curse her and transform her into an owl.
She brings the wisdom that beauty is only skin deep, hope, charity and a reminder that relationships can be fragile. Her name literally translates as 'flower face'.

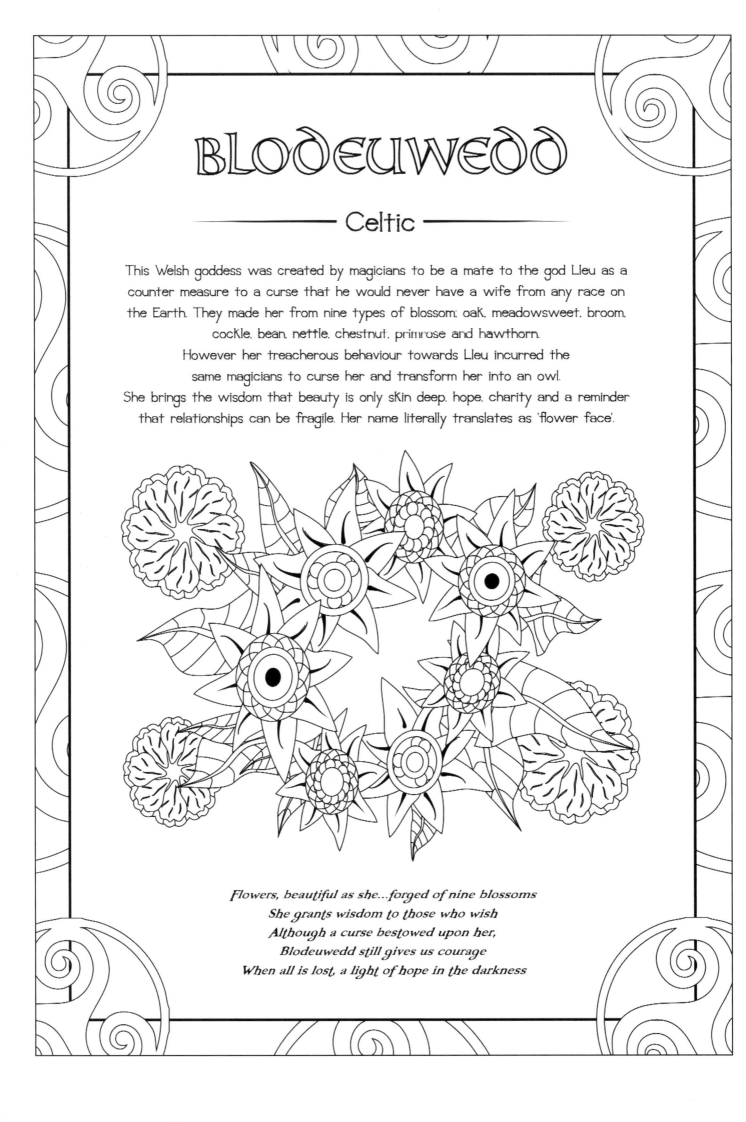

Flowers, beautiful as she...forged of nine blossoms
She grants wisdom to those who wish
Although a curse bestowed upon her,
Blodeuwedd still gives us courage
When all is lost, a light of hope in the darkness

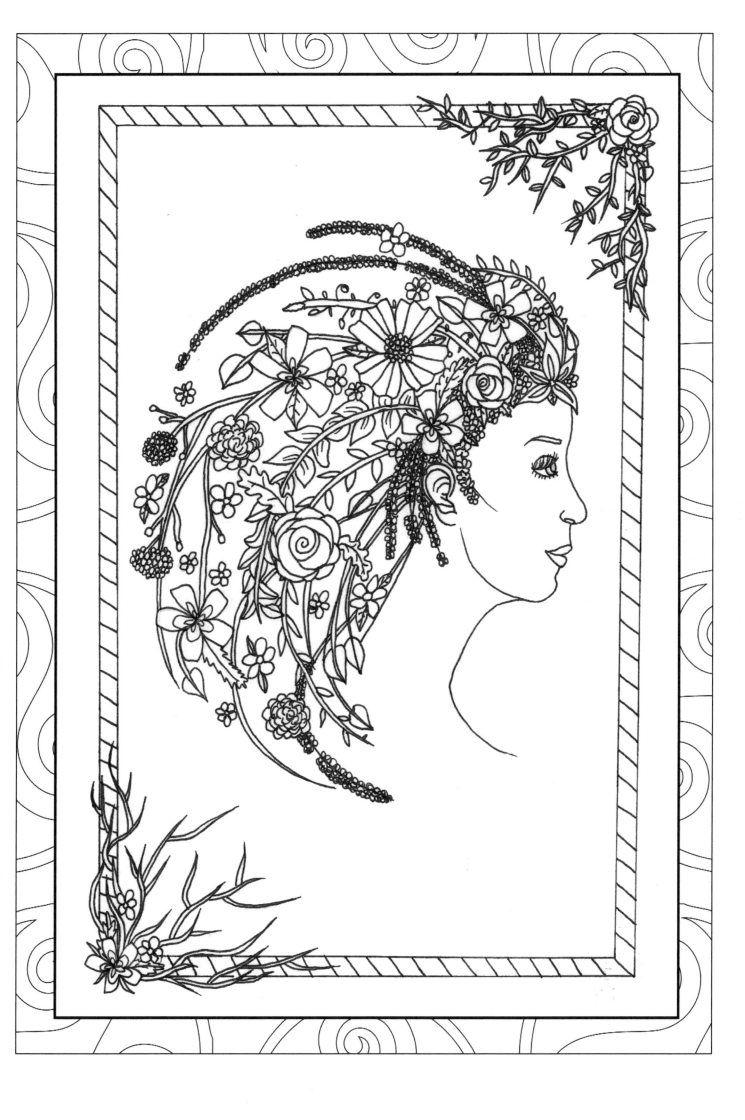

BRIGHID

— Celtic —

Brighid is an Irish goddess of healing, inspiration and creativity.
She is holder of the sacred flame, the flame of inspiration & a goddess of
fertility, smith craft and poetry. Also a warrior and protector she brings
the promise of spring after the long, dark months of winter.
Brighid is often associated with healing waters, springs and wells.
Her energy is bright, fiery and full of creative vibes as she illuminates
our talents and gifts. Brighid brings our muse and the free flowing power
of inspiration. She inspires, encourages and empowers us.

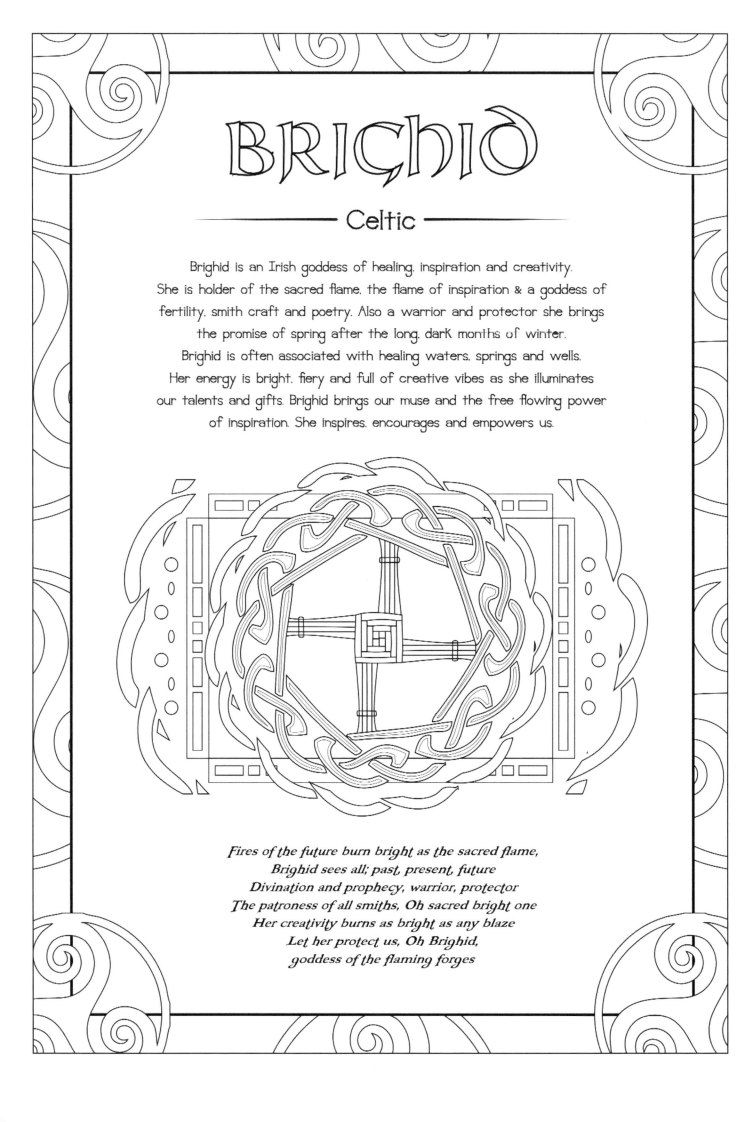

Fires of the future burn bright as the sacred flame,
Brighid sees all; past, present, future
Divination and prophecy, warrior, protector
The patroness of all smiths, Oh sacred bright one
Her creativity burns as bright as any blaze
Let her protect us, Oh Brighid,
goddess of the flaming forges

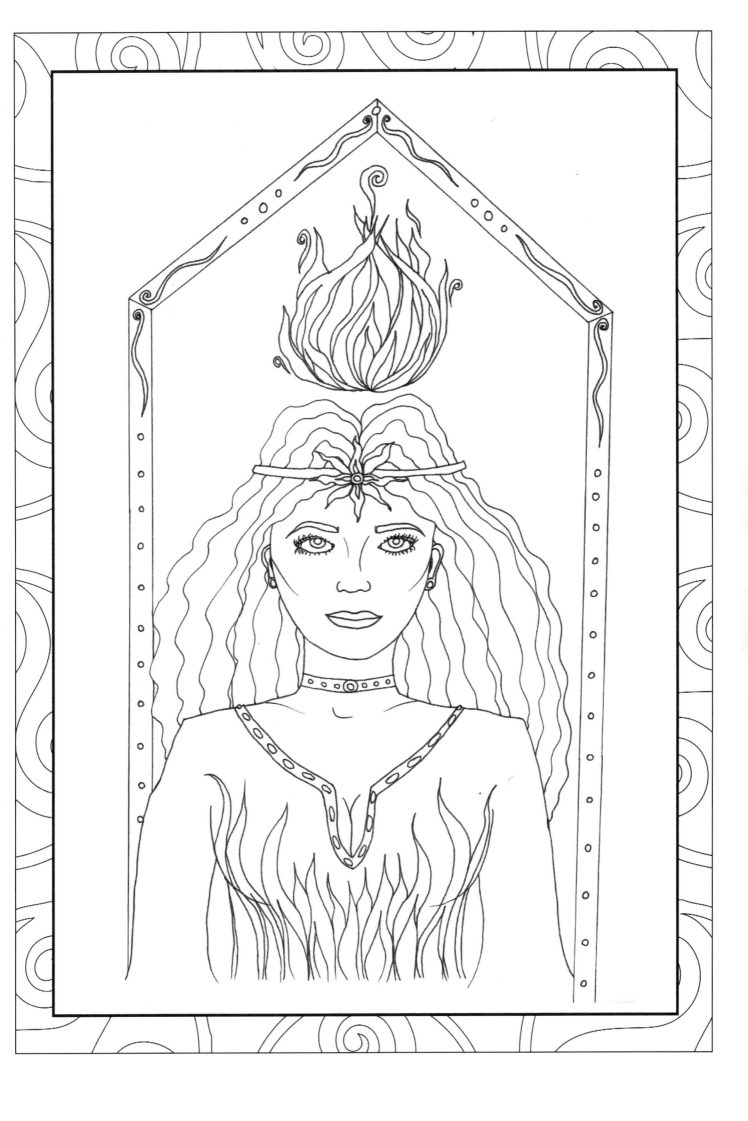

CERRIDWEN

— Celtic —

Cerridwen is the Welsh goddess of magic and transformation. and is Keeper of the
cauldron of inspiration filled with her brew of Awen (divine spirit and inspiration).
Her name translates as 'white sow' or 'white crafty one'.
She created a brew of wisdom for her son that was accidentally taken by
servant boy Gwion instead. whom she chased shape shifting into a hound.
a rabbit. an otter. a hawk and finally a black hen where she pecked Gwion up
after he changed into a grain of wheat to hide from her.
He grew in her belly and she gave birth to Taliesin. one of the greatest bards.
She is the changing seasons. inspiration. mother. fertility.
creativity. knowledge and the harvest.

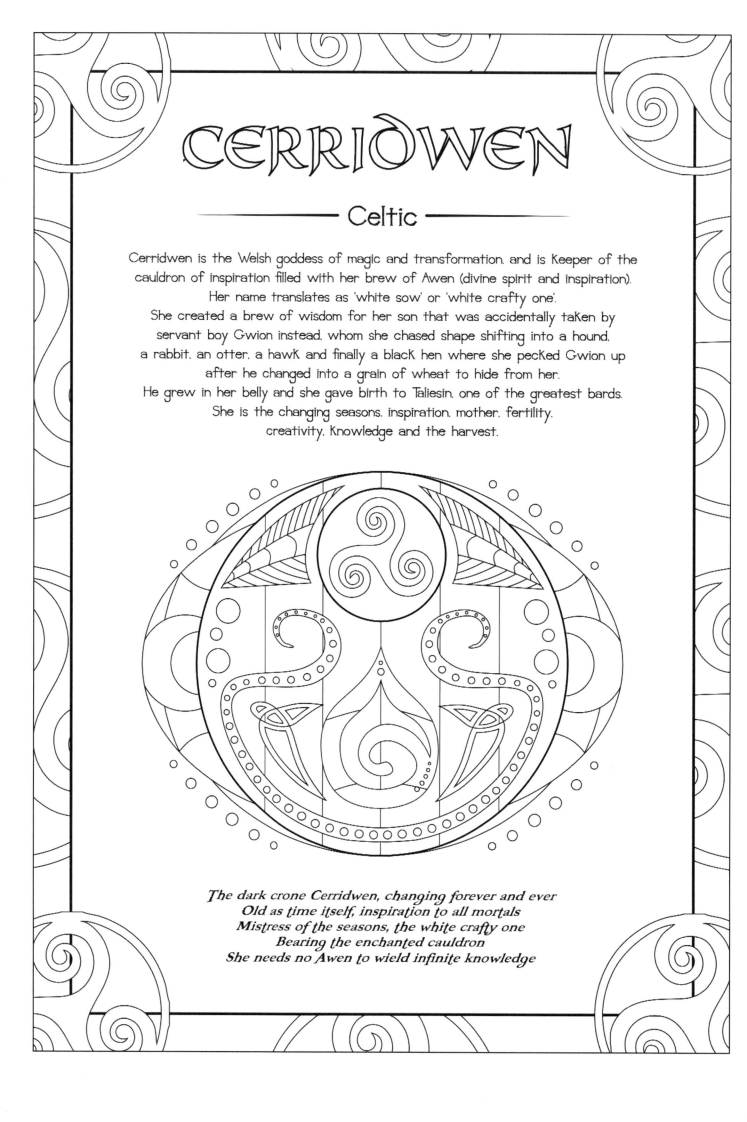

The dark crone Cerridwen, changing forever and ever
Old as time itself, inspiration to all mortals
Mistress of the seasons, the white crafty one
Bearing the enchanted cauldron
She needs no Awen to wield infinite knowledge

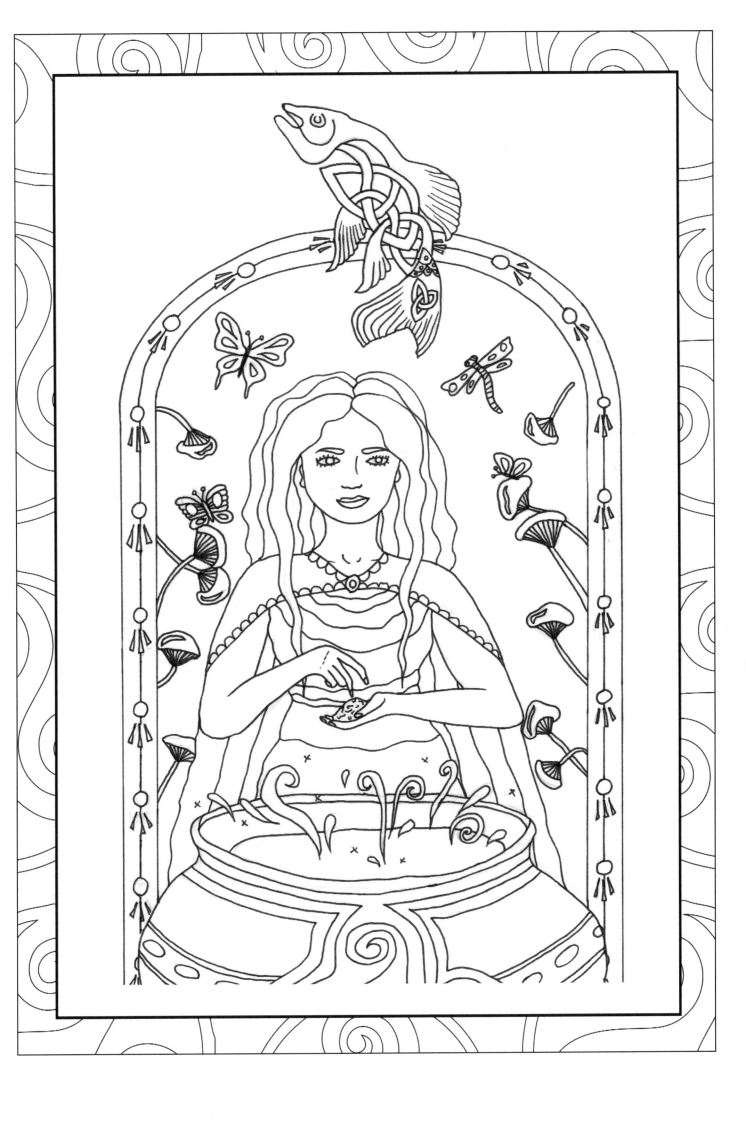

ELEN OF THE WAYS

— Celtic —

Elen of the Ways is an ancient British goddess and antlered Lady of the Wildwoods.
She is protector of the paths and track ways whether they are physical.
mental or spiritual. She is guardian of all those that take the journey.
Elen is the heartbeat of the woods. forests. moors and heath lands.
You will only find her if you seek her in the wild and dark places.
Her antlers signify her free spirit and connection to nature.
Follow the foot prints of the cloven hoof deer and you will find her.

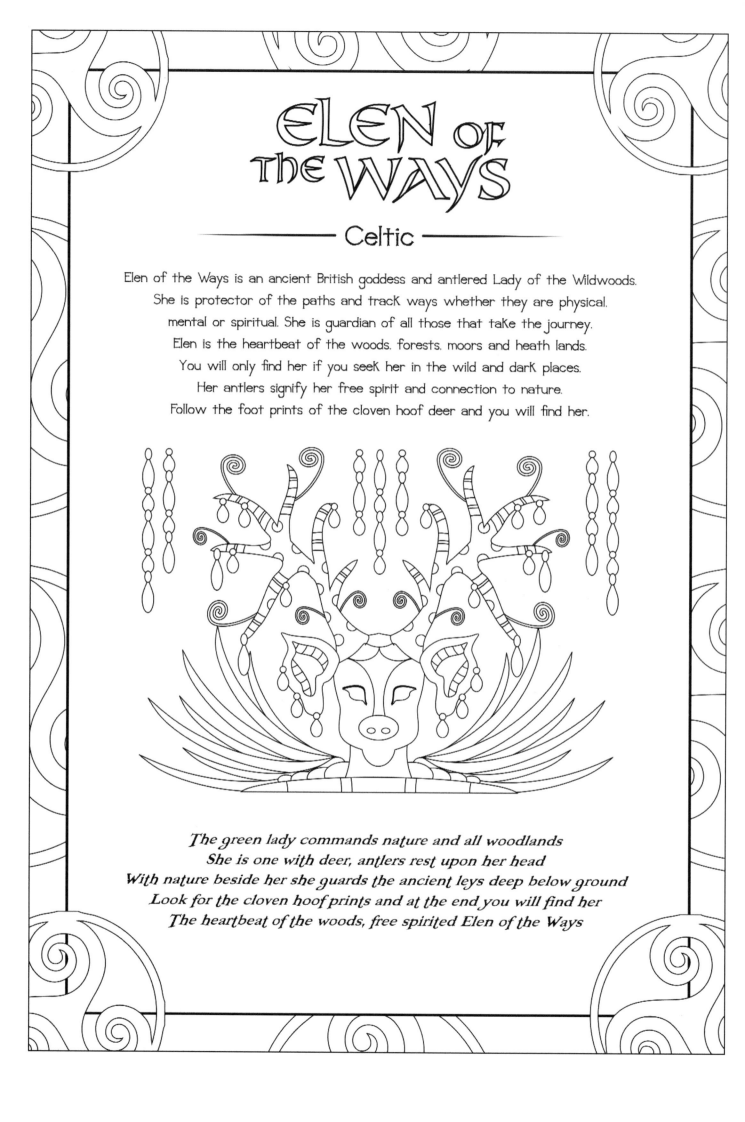

The green lady commands nature and all woodlands
She is one with deer, antlers rest upon her head
With nature beside her she guards the ancient leys deep below ground
Look for the cloven hoof prints and at the end you will find her
The heartbeat of the woods, free spirited Elen of the Ways

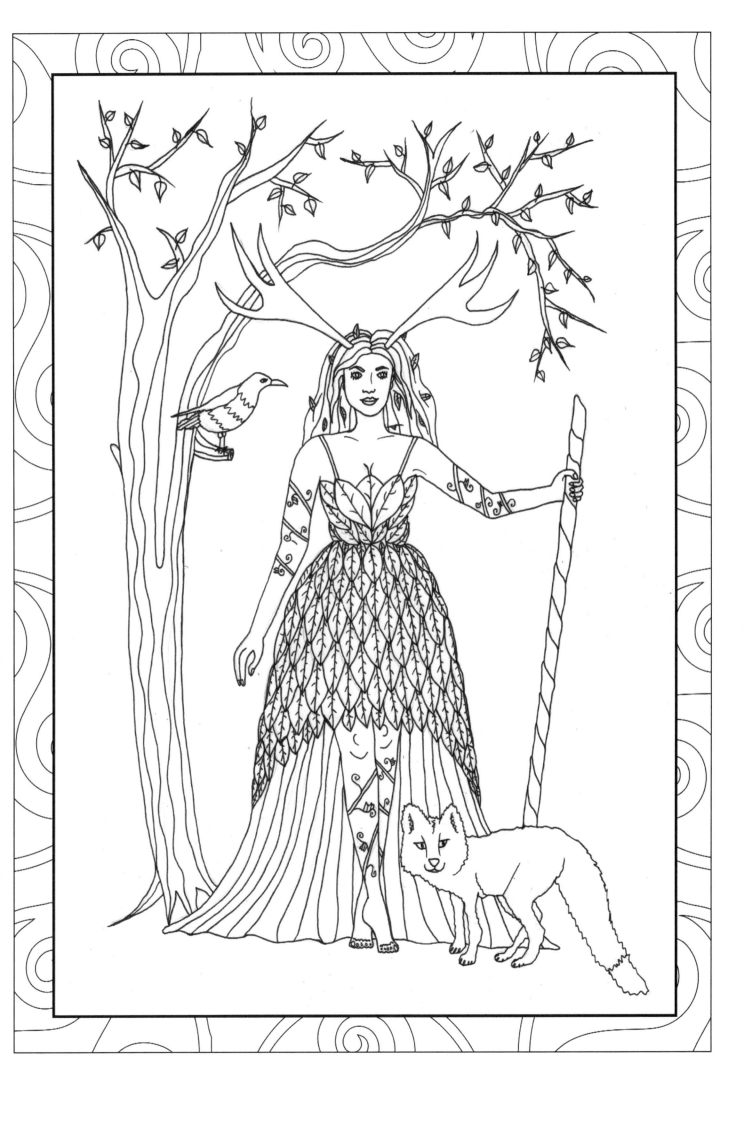

HORNED GOD

— Celtic —

The Horned God is the consort of the goddess and the male energy in
the form of the divine. He is lord of the woods, the hunt and all animals.
He is lord of fertility, life, death and the Otherworld.
He has many names in many cultures: Cernunnos.
Herne the Hunter and Pan to name but a few.
The Celts Know him as Cernunnos who guards the portal to the Otherworld.
As the British Horned God, Herne the Hunter he leads the Wild Hunt.
Whatever name or form he takes he brings strength, virility, loyalty and
courage and brings the life force of creation and the spirit of wild nature.

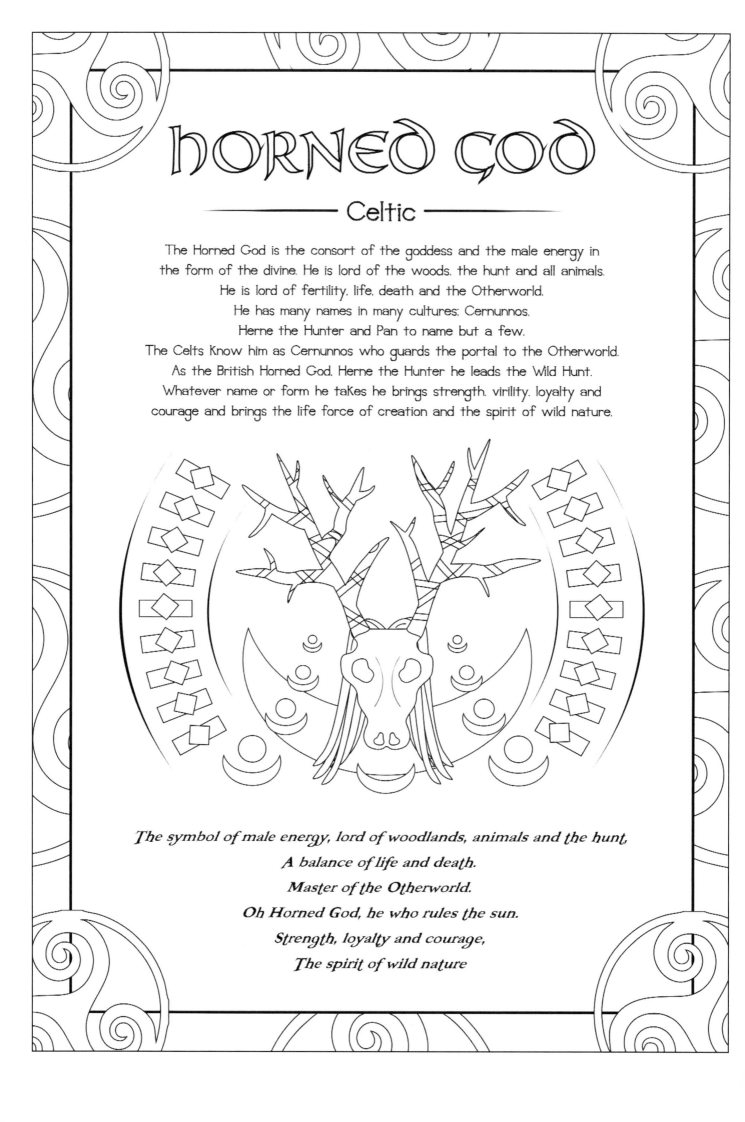

The symbol of male energy, lord of woodlands, animals and the hunt,
A balance of life and death.
Master of the Otherworld.
Oh Horned God, he who rules the sun.
Strength, loyalty and courage,
The spirit of wild nature

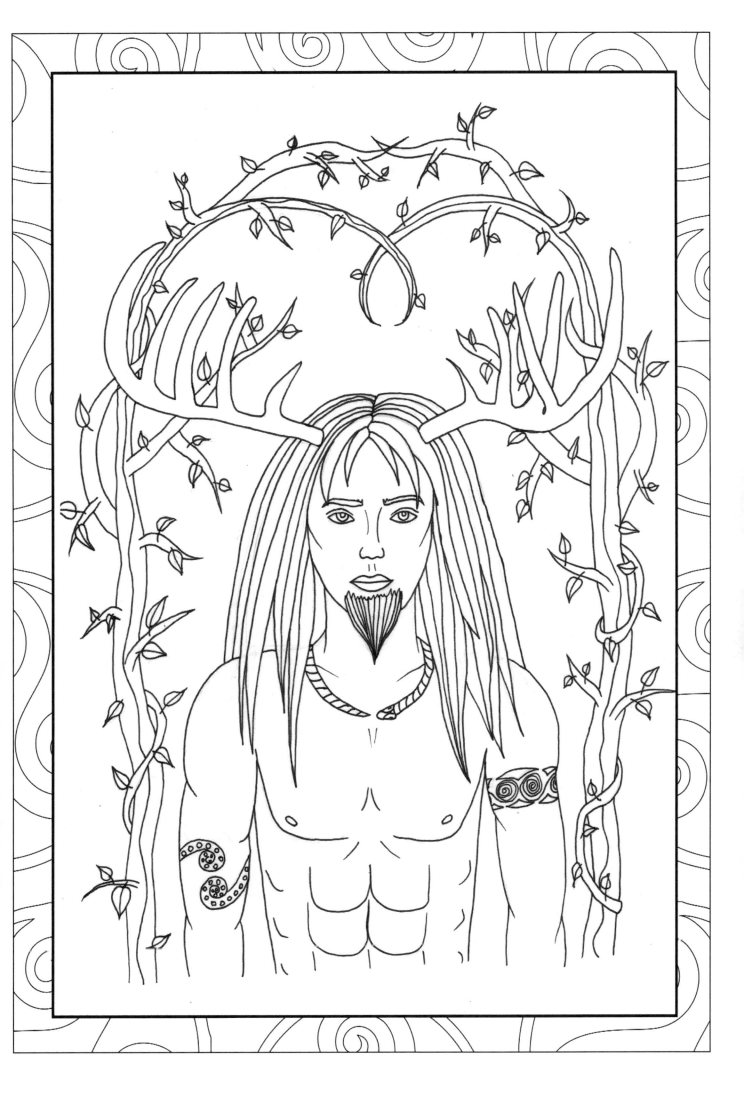

THE MORRIGAN

— Celtic —

The Morrigan. Great Queen and Phantom Queen she
represents the circle of life: birth. death and renewal.
A water goddess ruling over rivers and lakes. she is also a shape shifter.
Goddess of fate. war and battle she is associated with wisdom. prophecy.
magic and the land. She was said to hover over battlefields in the form
of a raven or a hooded crow and would foretell or influence the
outcome. then summon the souls of the slain soldiers.

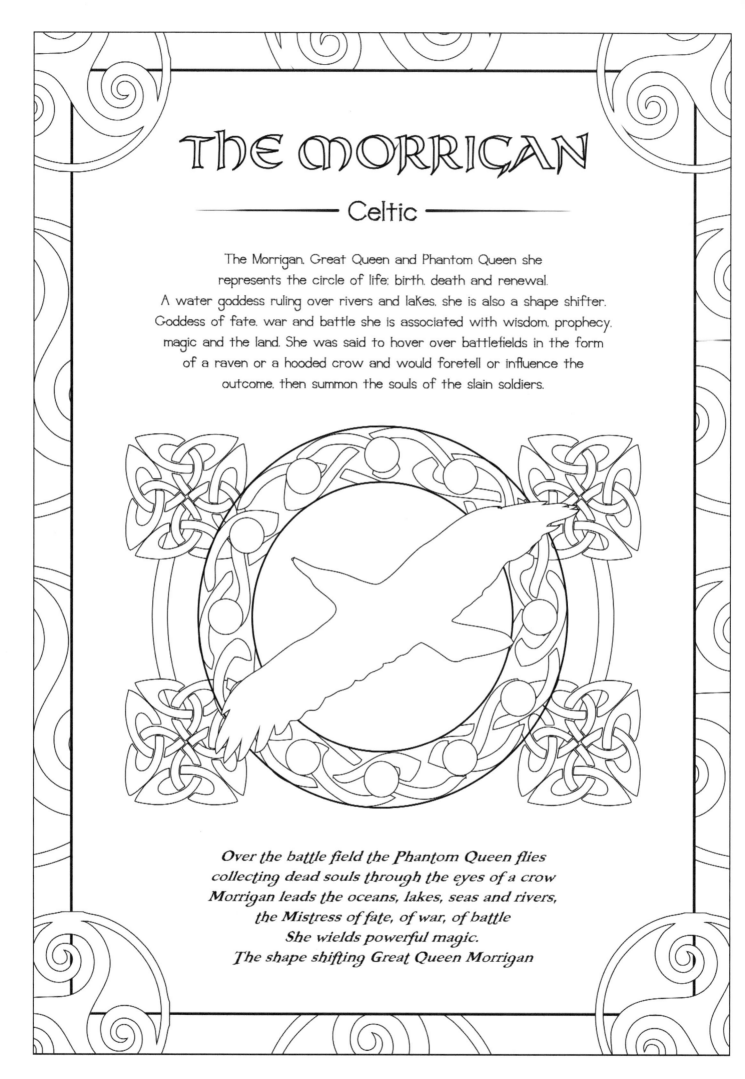

Over the battle field the Phantom Queen flies
collecting dead souls through the eyes of a crow
Morrigan leads the oceans, lakes, seas and rivers,
the Mistress of fate, of war, of battle
She wields powerful magic.
The shape shifting Great Queen Morrigan

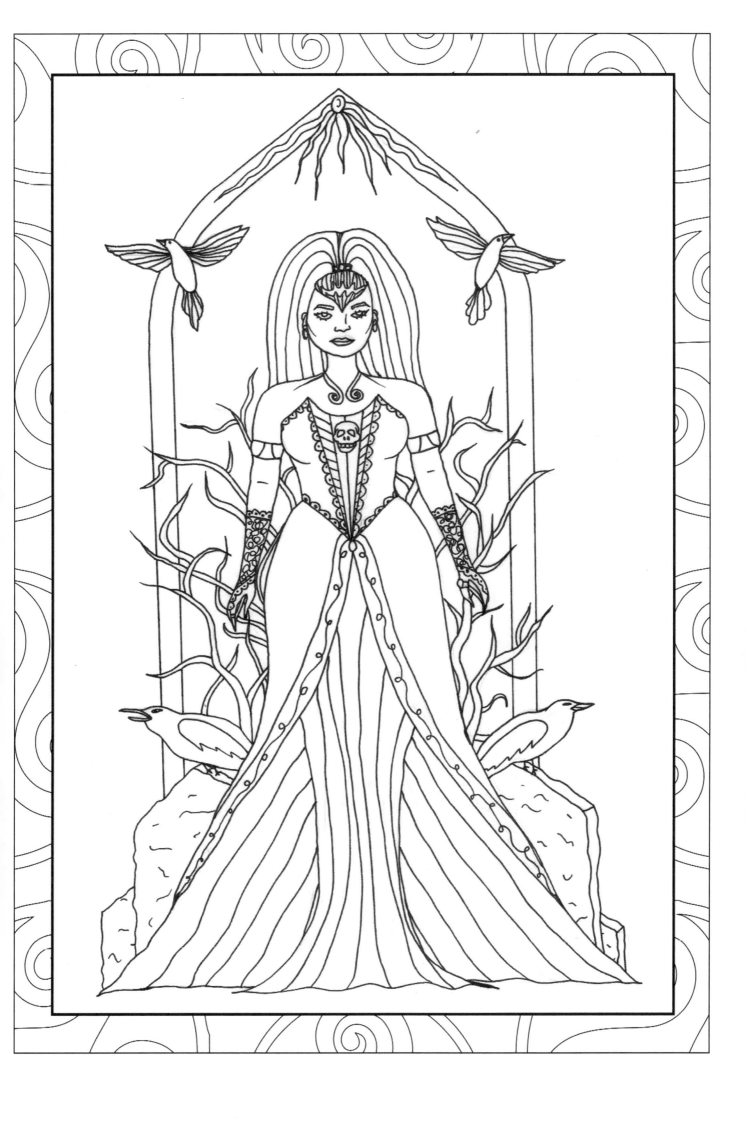

OAK & HOLLY KINGS

— Celtic —

The Oak King and the Holly King go to battle twice a year and the outcome is always set. At the winter solstice they fight and the Oak King wins to rule over the waxing half of the year, bringing the strength of the sunlight back to the world. They fight each other again at the summer solstice, this time the Holly King wins the conflict to rule the waning half of the year as the days shorten and the land prepares for its winter slumber. They are both gods of nature and bring the connection of fertility, the land and the seasons.

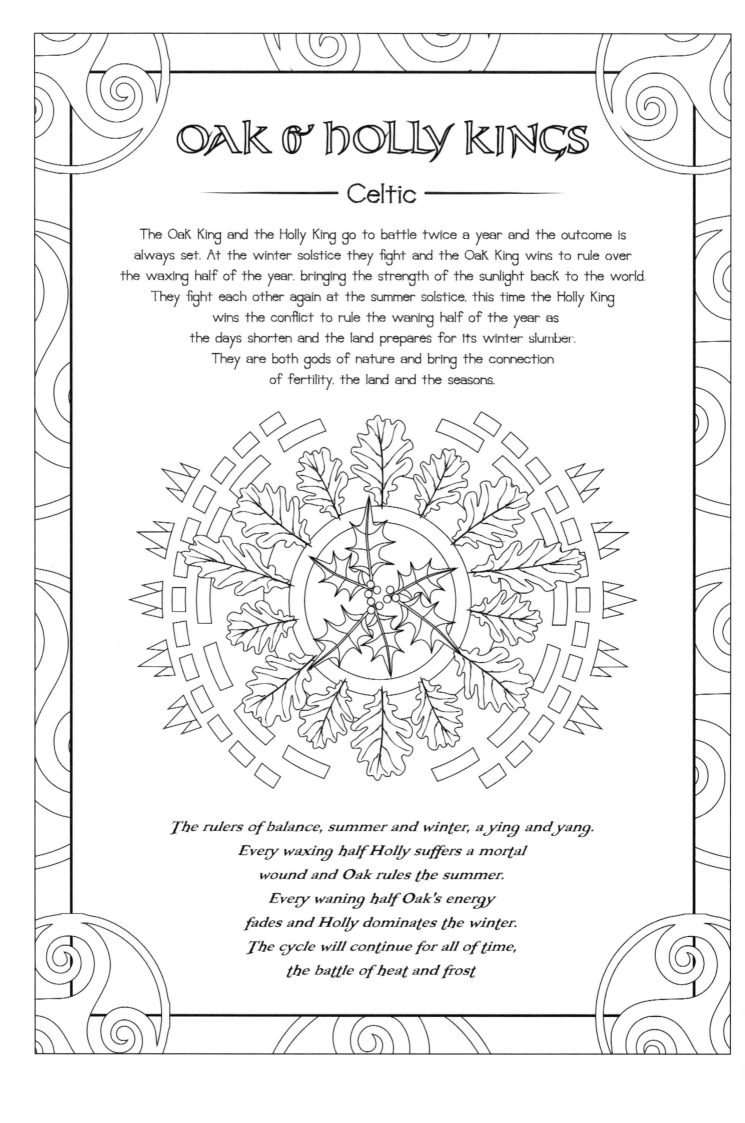

The rulers of balance, summer and winter, a ying and yang.
Every waxing half Holly suffers a mortal
wound and Oak rules the summer.
Every waning half Oak's energy
fades and Holly dominates the winter.
The cycle will continue for all of time,
the battle of heat and frost

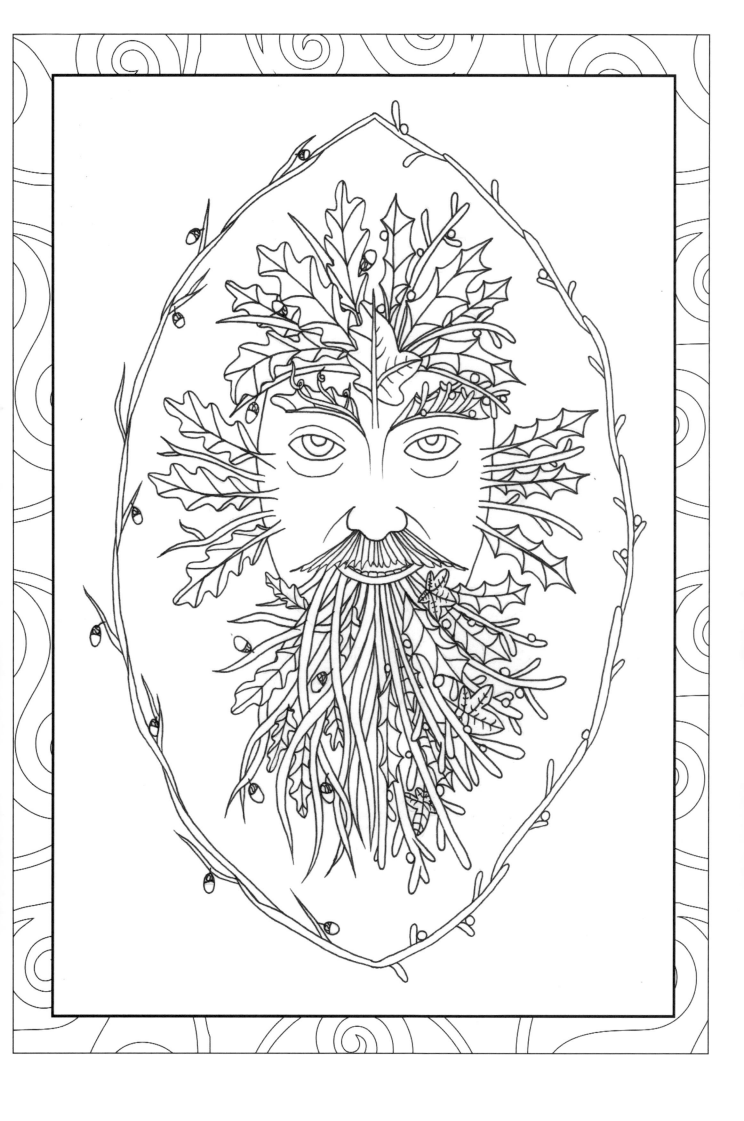

ANUBIS

— Egyptian —

Anubis is a god of death who guides souls through the dark
to the chamber of judgement. He is recognisable by his jackal head
and his name translates as 'royal child' or 'young dog'.
Anubis is a messenger of the gods, patron of mortuaries and overseer
of the Hall of the Two Truths, where the dead meet their judgement.
His spirit also presides over the embalming process
and the journey of departed souls.

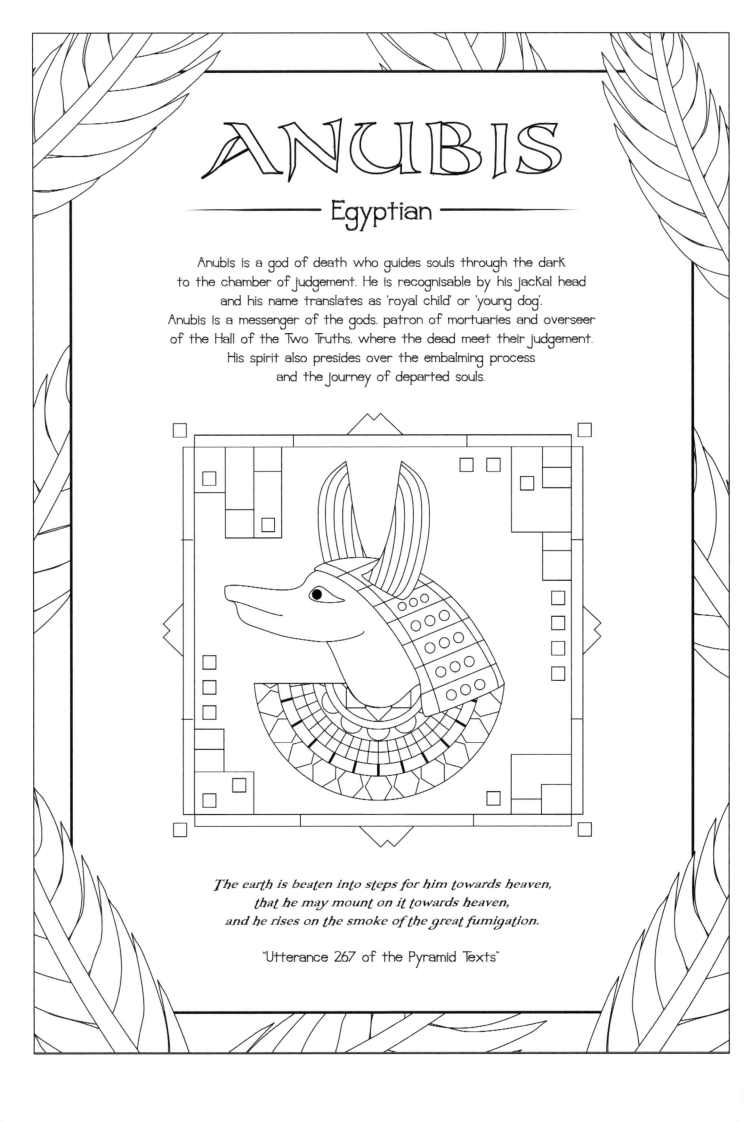

*The earth is beaten into steps for him towards heaven,
that he may mount on it towards heaven,
and he rises on the smoke of the great fumigation.*

"Utterance 267 of the Pyramid Texts"

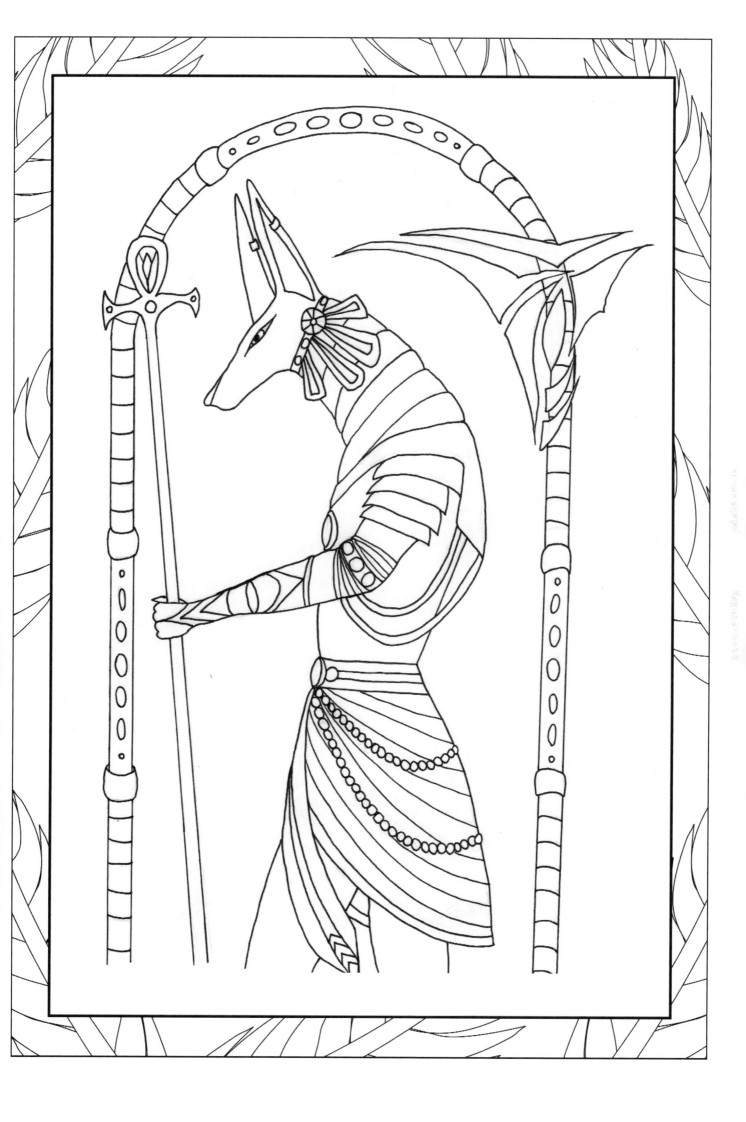

BAST

─ Egyptian ─

Bast is a goddess of pleasure, the occult, magic, health and
the household. Also, her name translates as 'she of the Bast'
(ointment jar). She protects the god Ra from his enemies and
is known as the Lady of the East and the Goddess of the
Rising Sun. Although by night she shape shifts into a cat.
Some images show her with a cat head and earlier ones with the
head of a lioness. She has become the patron goddess of cats.

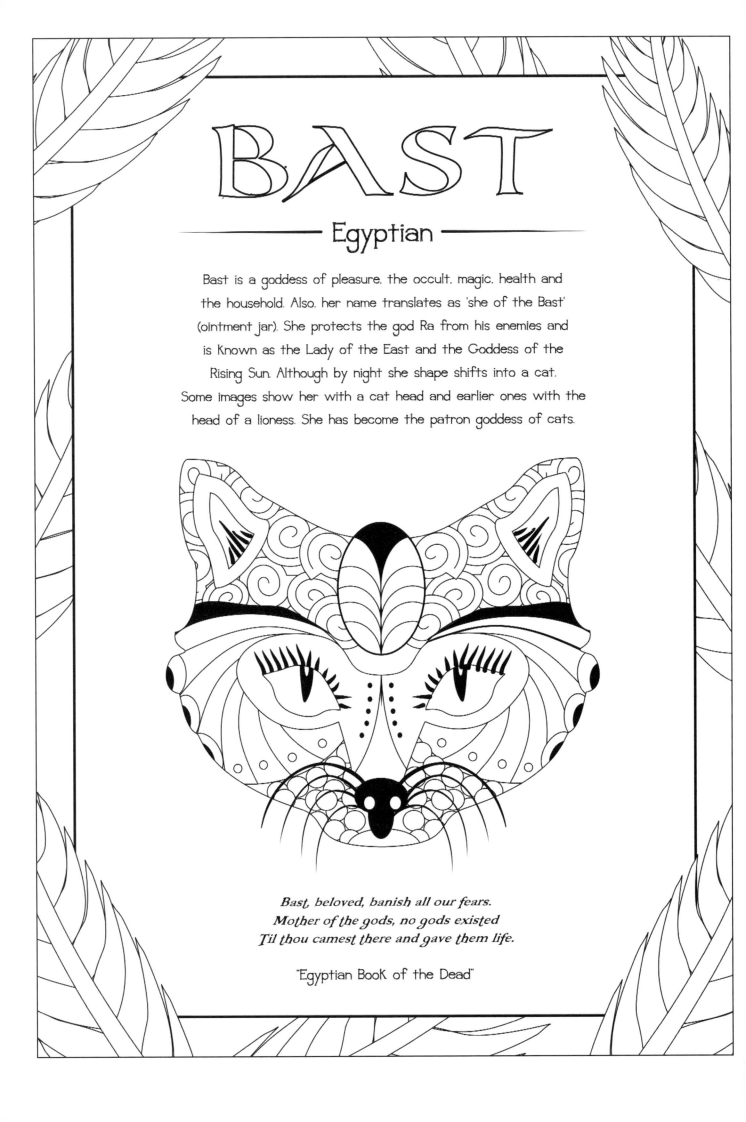

Bast, beloved, banish all our fears.
Mother of the gods, no gods existed
Til thou camest there and gave them life.

"Egyptian Book of the Dead"

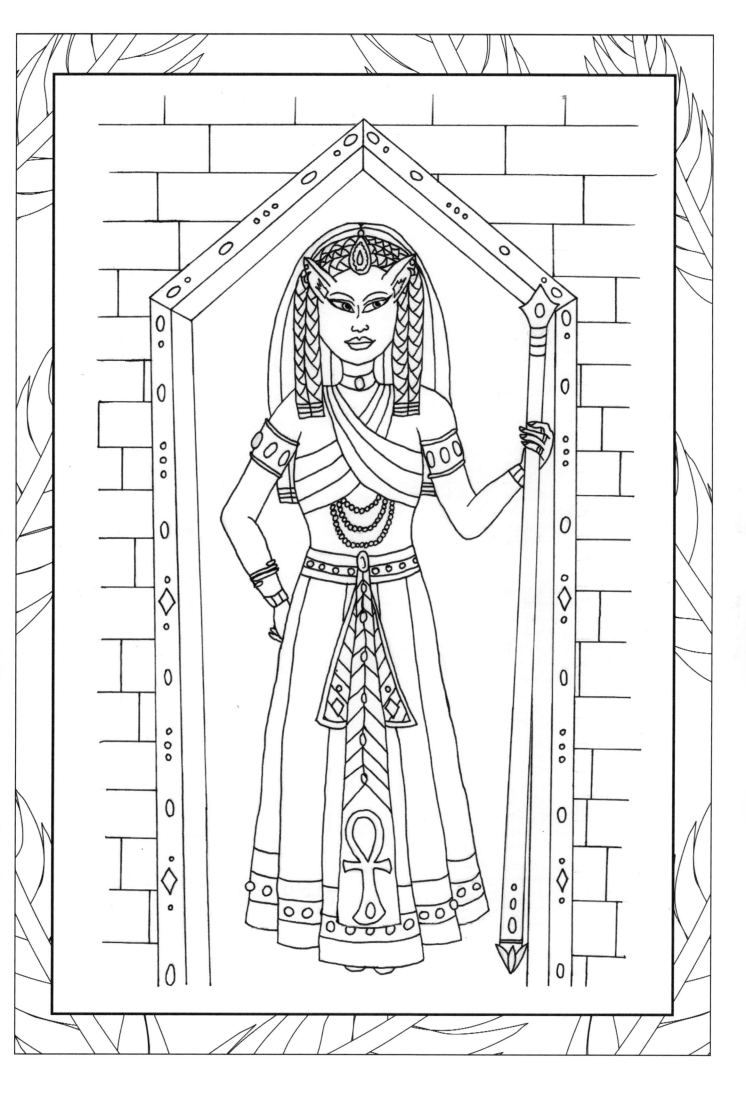

HATHOR

— Egyptian —

Hathor is deeply loved and revered by women who aspire
to emulate her roles as a wife, mother and lover.
She is considered to be mother to all the Pharoahs.
Her name translates as 'the house of Horus' and she gave birth to
gods, shaped men and animals and coaxes nature into life.
She banishes the shadows, she brings light into being and
the river Nile and the winds are both under her control.
She is worshipped as the embodiment of the sky in her role
of the Celestial Cow.

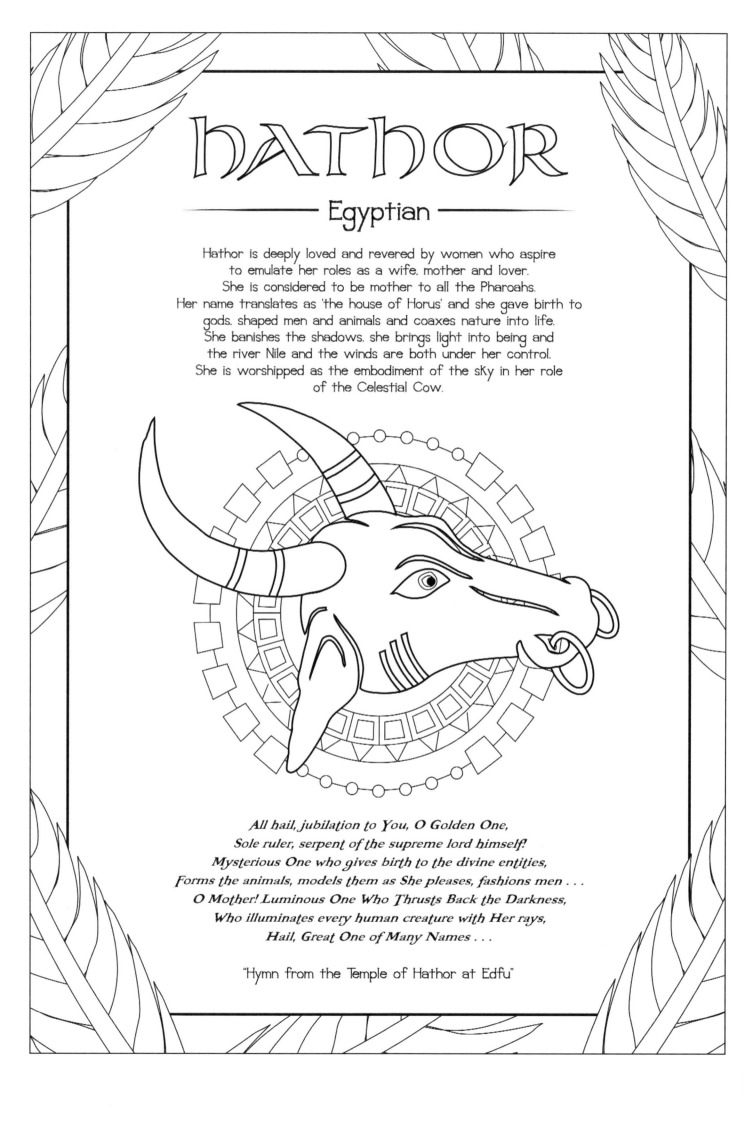

All hail, jubilation to You, O Golden One,
Sole ruler, serpent of the supreme lord himself!
Mysterious One who gives birth to the divine entities,
Forms the animals, models them as She pleases, fashions men . . .
O Mother! Luminous One Who Thrusts Back the Darkness,
Who illuminates every human creature with Her rays,
Hail, Great One of Many Names . . .

"Hymn from the Temple of Hathor at Edfu"

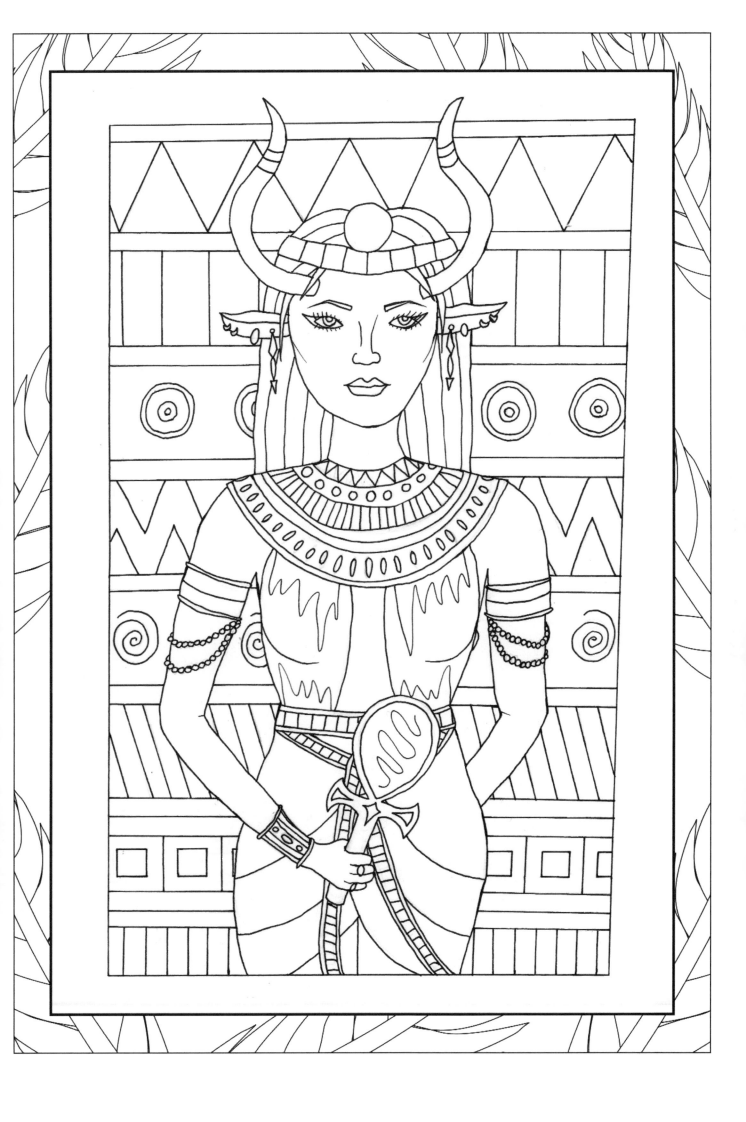

HORUS

— Egyptian —

All pharaohs were believed to be the human manifestation of the
god Horus. Horus is often depicted as a falcon headed man wearing
a sun disk or double crown. The sun and the moon represent the
two eyes of Horus and his name translates as 'the distant face above'
or 'the high one'. it also means 'falcon'. The speckled feathers of
his breast are the stars and his wings the sky.
Horus is a war god and a patron of young men and hunters.
He is also associated with the planets Jupiter, Mars and Saturn.

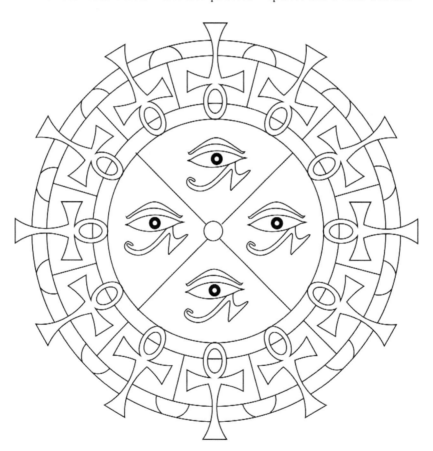

He is Horus who arose as King of upper and lower Egypt
Who united the two lands in the name of the wall
The place in which the two lands were united.

"The Shabaka Stone"

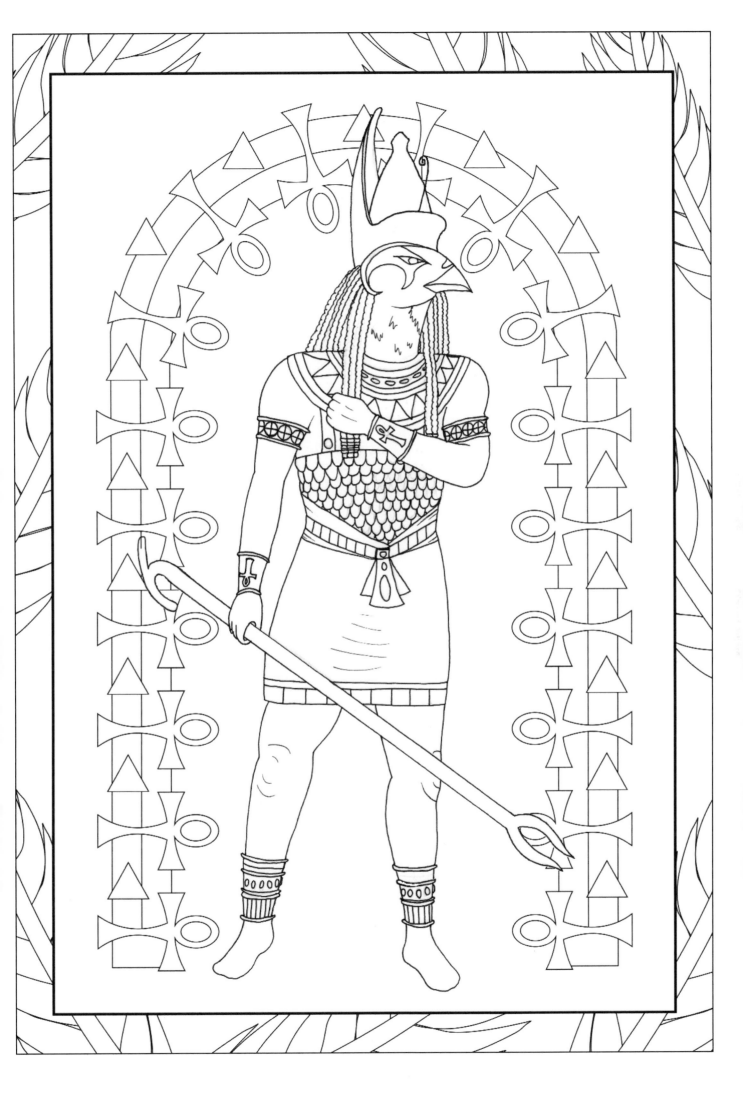

ISIS

— Egyptian —

Isis is both Queen of Egypt and goddess of magic and healing.
She is also the patroness of women and children
and protects marriage and vows of love.
Using her wisdom and sorcery she strengthens ancestral
bonds and brings about change and transformation.
As a shape shifter Isis can transform into her totem bird.
which is why images often depict her with wings.

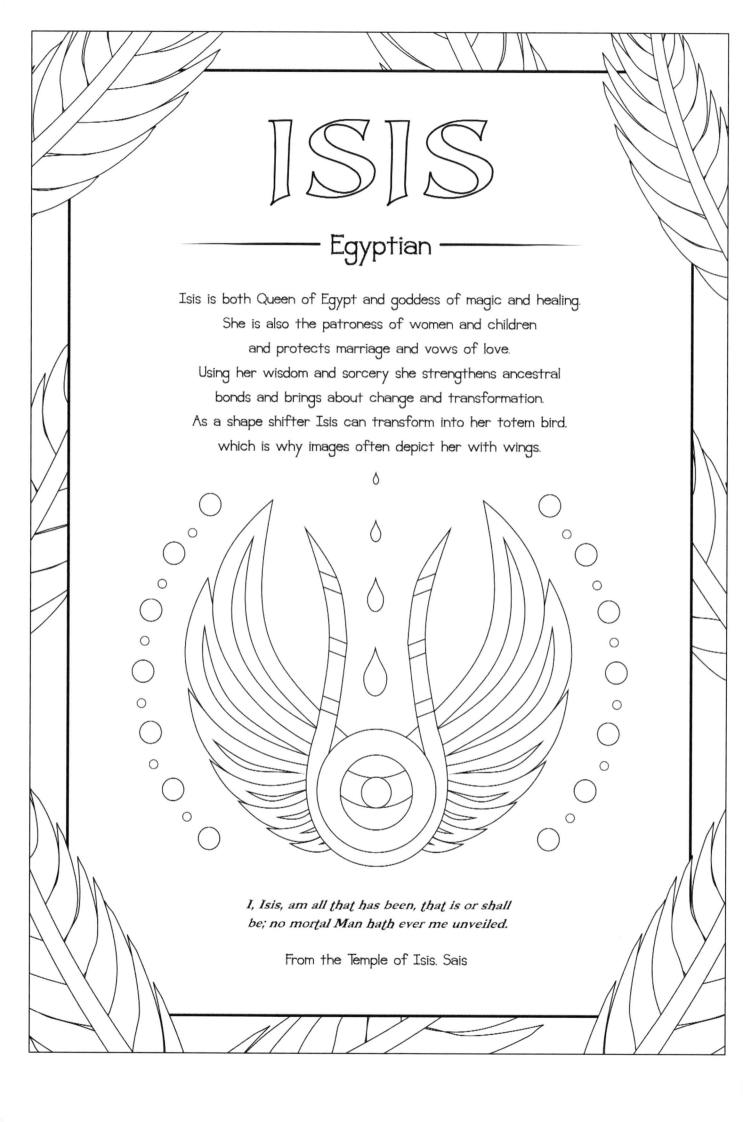

*I, Isis, am all that has been, that is or shall
be; no mortal Man hath ever me unveiled.*

From the Temple of Isis. Sais

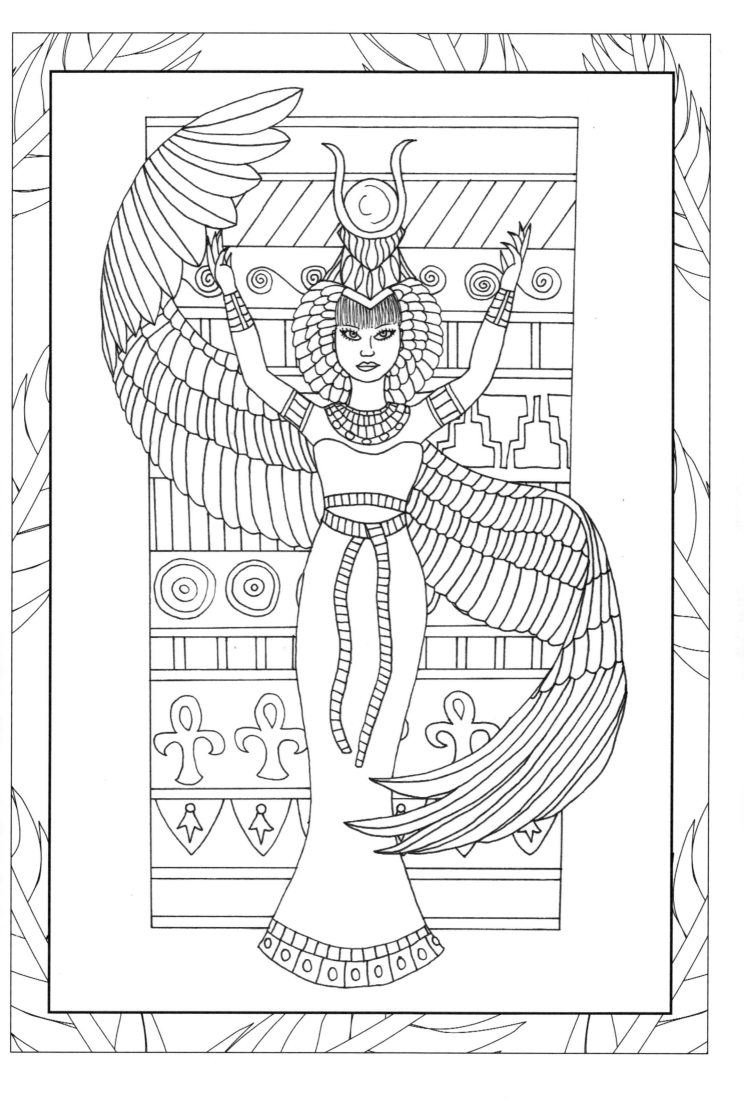

MA'AT

Egyptian

Ma'at is the goddess of truth, law, justice and balance. Her name translates as 'that which is straight' meaning truth, order and balance. She also represents the natural order of things and the stability of the universe. On the Day of Judgement the heart of the dead is weighed on the scales of justice in Maaty (The Hall of Two Truths) balanced by the feather of Ma'at (the sacred ostrich feather of Ma'at was the symbol of truth). Ma'at stepped in after the universe was created and brings harmony to the chaos and disorder.

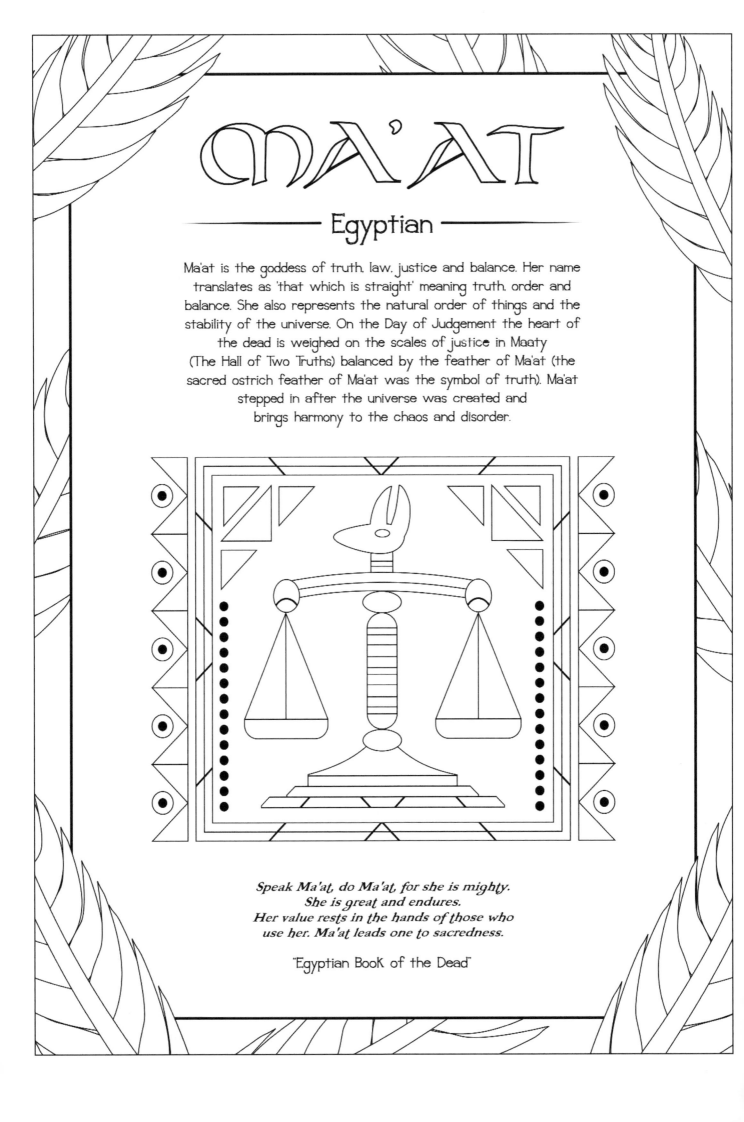

Speak Ma'at, do Ma'at, for she is mighty.
She is great and endures.
Her value rests in the hands of those who
use her. Ma'at leads one to sacredness.

"Egyptian Book of the Dead"

RA

Egyptian

Ra is an important solar deity and his name translates as
'creative power' or 'the creator'. He is the spirit of the sun
and embodies the strength of heat, light and majesty.
The 'Eye of Ra' is another name for the sun, depicted as a
man with a falcon head he wore a sun disk headdress,
and his gold face was said to illuminate the sky. Ra carries the
prayers and blessings of the living along with the souls of the
dead on his sunboat. Prayers and hymns are said to help Ra
and the sunboat overcome the dangers of the Duat which they
pass through including the serpent Apophis.
After his death a pharaoh is said to ascend to join Ra's entourage.

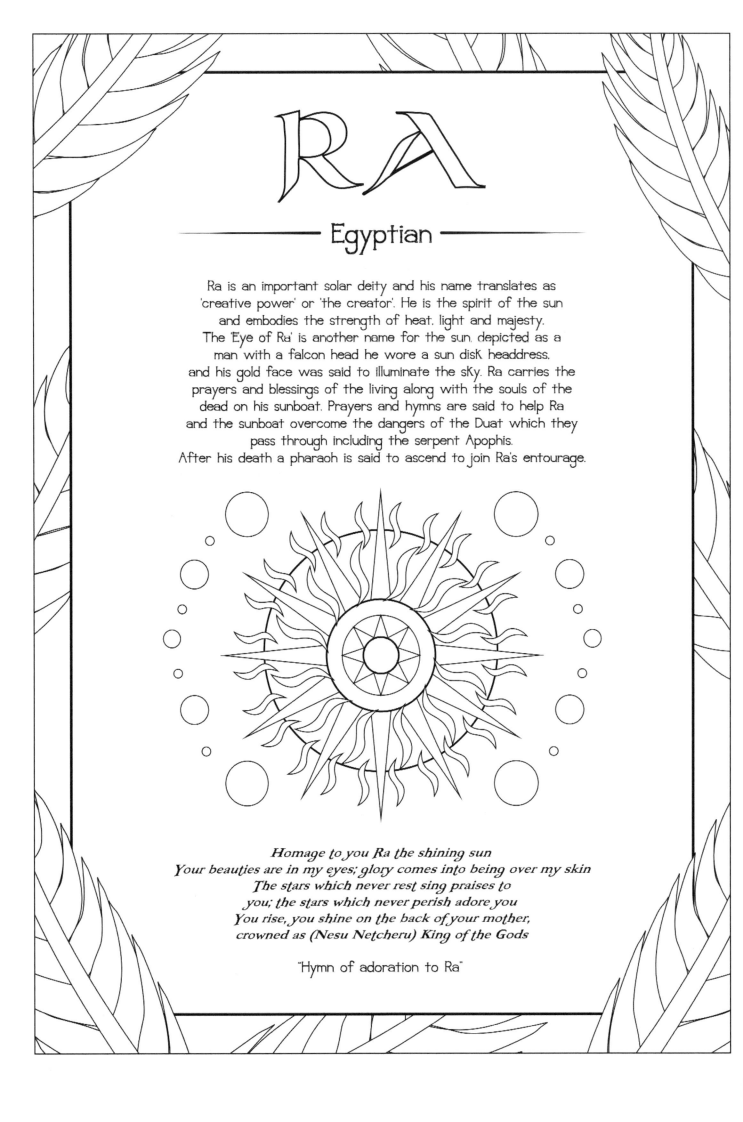

Homage to you Ra the shining sun
Your beauties are in my eyes; glory comes into being over my skin
The stars which never rest sing praises to
you; the stars which never perish adore you
You rise, you shine on the back of your mother,
crowned as (Nesu Netcheru) King of the Gods

"Hymn of adoration to Ra"

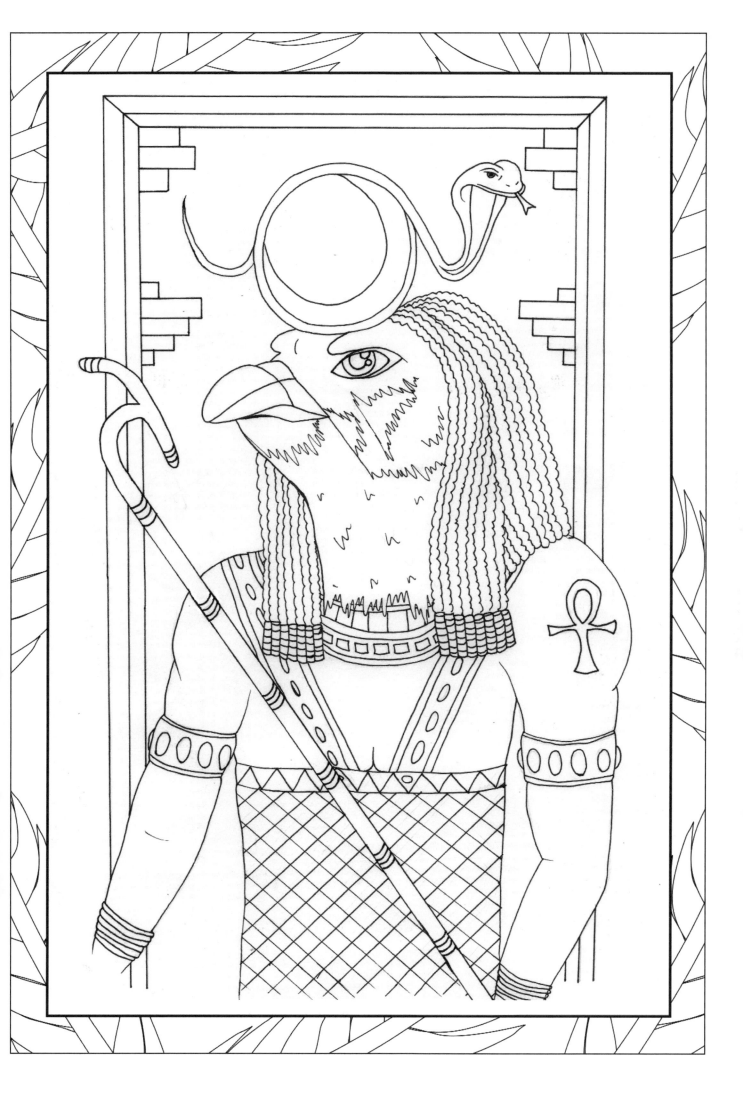

Thoth

— Egyptian —

Thoth is a deity of Knowledge, understanding, justice and truth.
His name translates as 'truth and time' and he is believed to have
'sung' several gods and goddesses into existence. Thoth was thought
to be the wisest of the gods and a patron of scribes.
He was said to have invented writing and the languages
including the first hieroglyphics and the Book of the Dead.
Myths suggest he created the 365 day calendar.
It is Thoth who places the heart of the dead on the Scales of
Truth and judges them worthy or not to enter the Kingdom of the
Dead. Thoth was claimed to be the original author of every piece
of work in all areas of Knowledge both human and divine.

Come to me, Thoth, O noble Ibis, O letter writer of the gods,
O great scribe, come to me and give me counsel,
Make me skilful in your calling!
Better is your calling than all callings, it makes men great
He who masters it is found fit to hold office.
I have seen many whom you have helped
Grant me your wisdom, O Thoth!

"Prayer to Thoth"

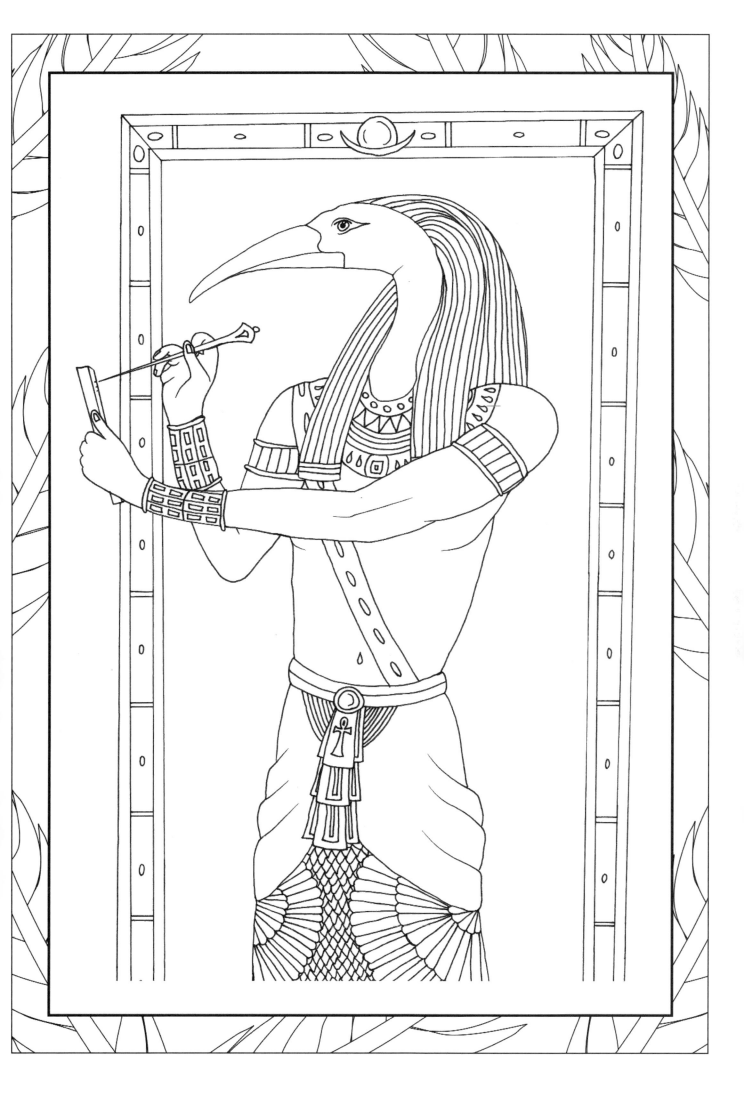

APHRODITE

— Greek —

Aphrodite is the Greek goddess of
love, sex, attraction, beauty and desire.
She not only has natural beauty but also possesses a
magical girdle that compels everyone to desire her.
There are two versions of her birth, one is that she was the child of
Zeus and Dione, the other is that she rose from the foam of the sea.
The gods believed that her beauty was such that it would cause a war between
them. Because of this Zeus married her off to Hephaestus, he wasn't
seen as a threat because of his deformity and great ugliness, but despite her
marriage she had many lovers.

This goddess' beauty, knows no bounds
It is so powerful many wars began
She grants pleasure and emotional luck to those that believe

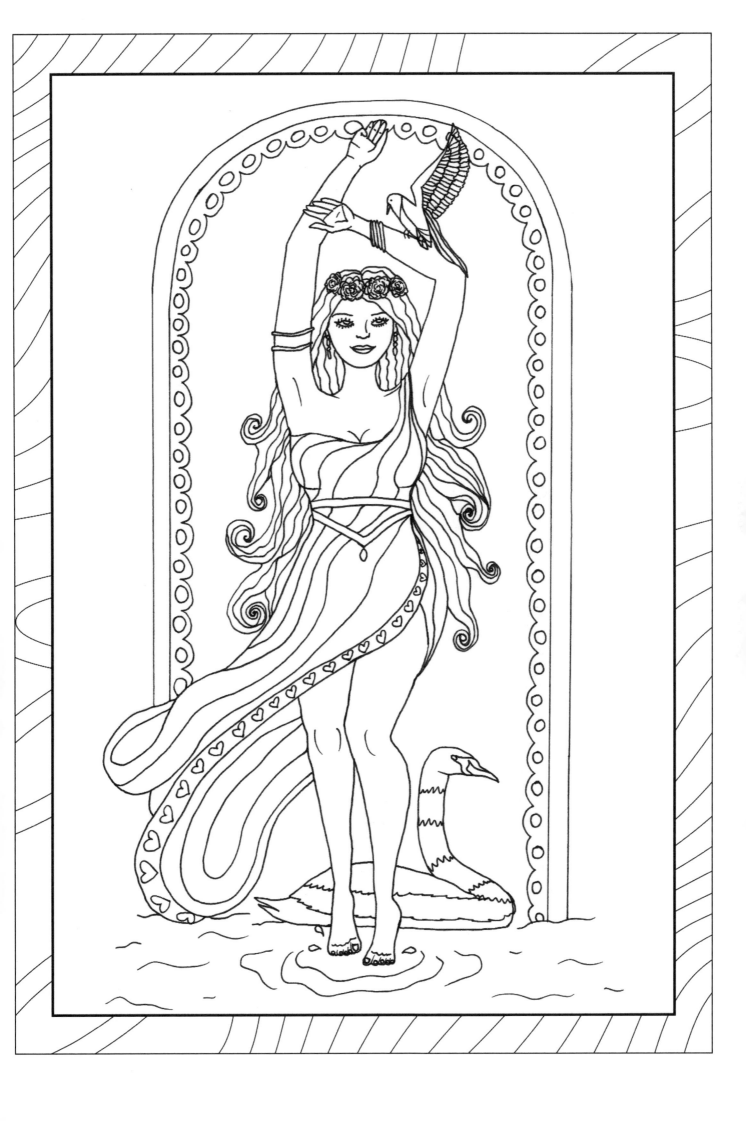

ARTEMIS

— Greek —

Artemis is a Greek goddess of chastity,
virginity, the hunt and the moon.
As soon as Artemis was born she helped her mother give birth to
her twin brother and therefore has a strong connection to childbirth.
She made a request to her father Zeus for eternal chastity and virginity, devoting
herself instead to nature and the hunt and becoming protector for both, along with
the care of animals and agriculture. She is often depicted accompanied by a hunting
dog or a stag. She also carries a bow and arrow said to have been
made by Hephaestus and Cyclops. The bear is sacred to her.

Protector of wild animals, nature and the hunt
She aids mothers in labour
And fires arrows from her mystical bow
Oh mighty hunter, Artemis

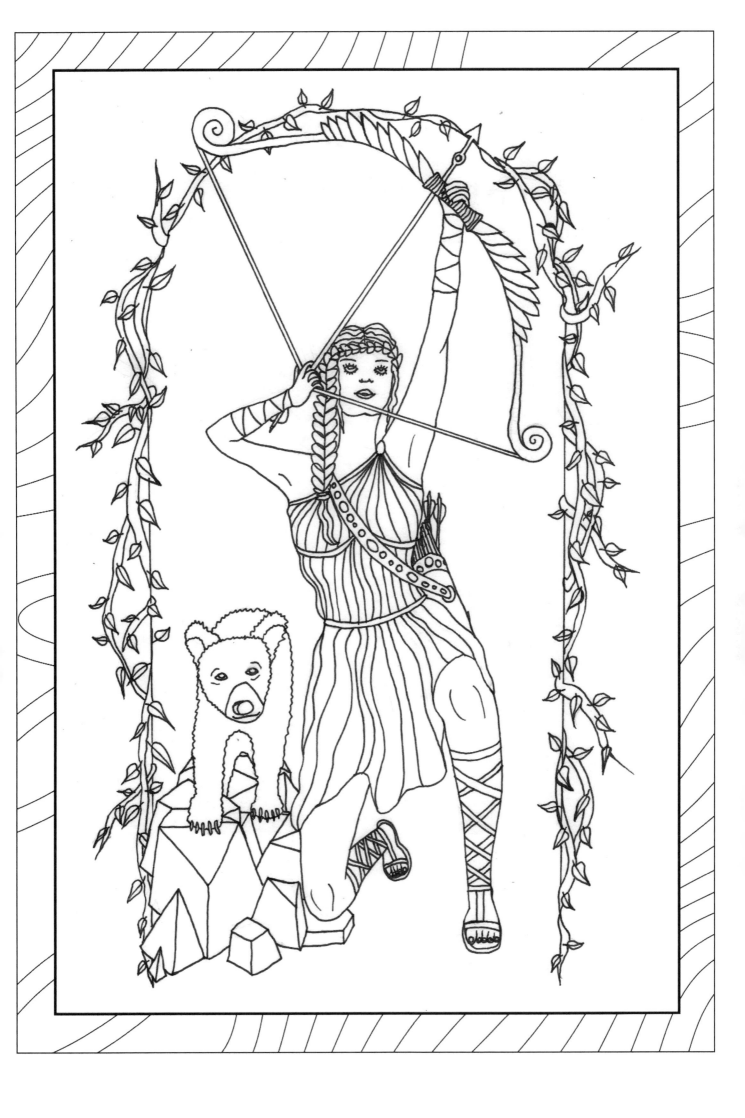

DEMETER

— Greek —

Demeter's daughter Persephone was abducted by
Hades to be his wife in the Underworld.
Angry at the treatment of her daughter. Demeter put a curse on
the world that caused all the plant life to wither and die.
Long story short...Persephone ended up spending four months of each year in the
Underworld and during that time Demeter grieves and the plants die.
When Persephone appears above ground again spring arrives.
Demeter is not only a goddess of the cycle of life and death but also a harvest
deity. bringing back fertility to the earth on the return of her daughter.

Harbinger of the harvest, bender of the seasons
Kind in the summer, heartless in the winter
Eagerly awaiting her beloved daughter's return
Lady of the crop, Demeter

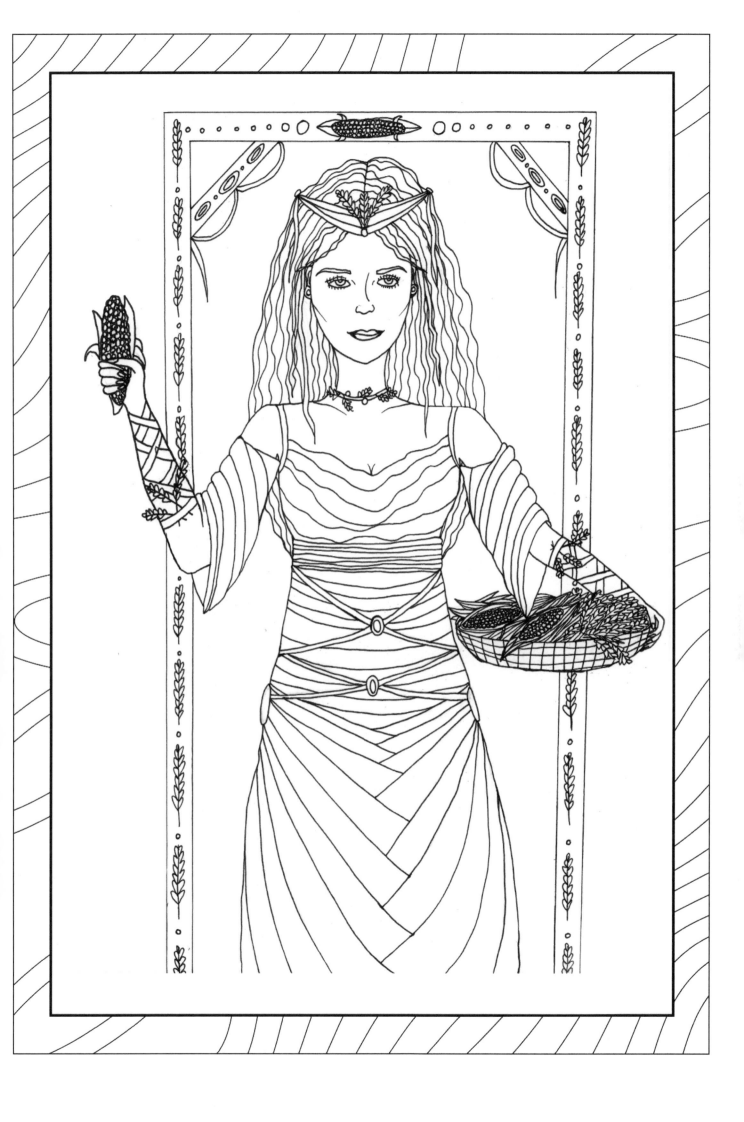

HEKATE

— Greek —

A Greek goddess of magic, witchcraft, the dark of night, dark
moon magic and ghosts. She has power over heaven, the earth
and the sea. HeKate is also a goddess of the crossroads.
HeKate is guardian of the household and protector of new borns.
She is a powerful goddess and one of the ancient Titans.
Zeus shared with her the power of giving humanity
whatever they wished for or withholding it.
HeKate walks the roads at night and visits places of the dead on the dark of the moon.
She is usually depicted carrying torches and accompanied by her sacred dogs.
HeKate is also sometimes seen with three heads: one of a snake,
one of a horse and the third a boar.

Goddess of the moon, caster of magic, changer of beginnings
She brings opportunities, clear as a white candle
She banishes the unwanted, the ghosts, the bad memories
Mistress of magic, Hekate

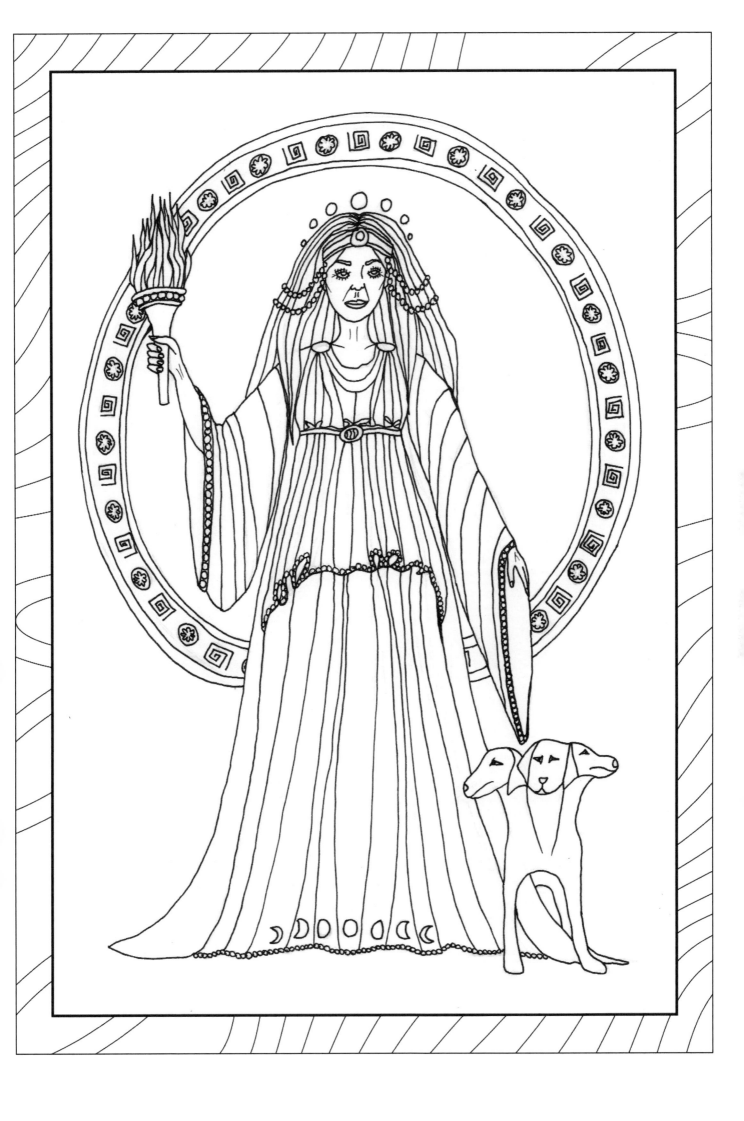

HESTIA

— Greek —

Hestia is a virgin Greek goddess of
the hearth, family and domestic home life.
Her name actually translates as 'house' or 'hearth'.
As a protector of the home she also presides over the
family meal and baking of bread. Goddess of the sacrificial flame,
she receives a share of every sacrifice made to the gods.
Often depicted as a veiled woman holding a flowering branch
Hestia also occasionally carries a Kettle.

Goddess of the hearth, of home life and family.
Mistress of the sacrificial flame, bearing a flowered branch.
Protecting the blood line, she had no human form.
The first harvest of fruits, the first animals,
the first water of each year, was gifted to her.
Great family goddess, Hestia

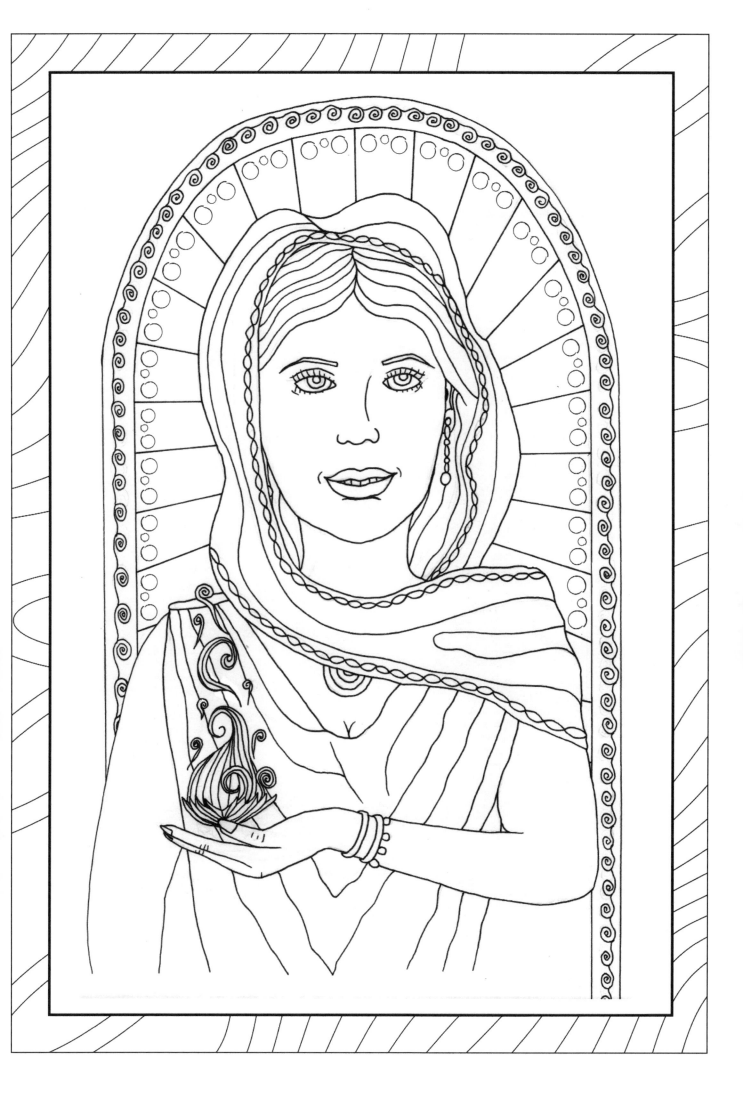

PERSEPHONE

— Greek —

Queen of the Underworld and unwilling wife of the god Hades.
Persephone is a goddess of spring, seized and taken to the Underworld; she
inadvertently ate a handful of pomegranate seeds which sealed her fate.
She had to stay in the Underworld for part of the year – the winter.
Her return to the world each year hails the beginning of spring.
Often depicted as a young goddess holding grain or a flaming
torch, she is sometimes shown beside Hades.
She represents youth, innocence and decision making.
She also brings a reminder of hope and all that it brings.

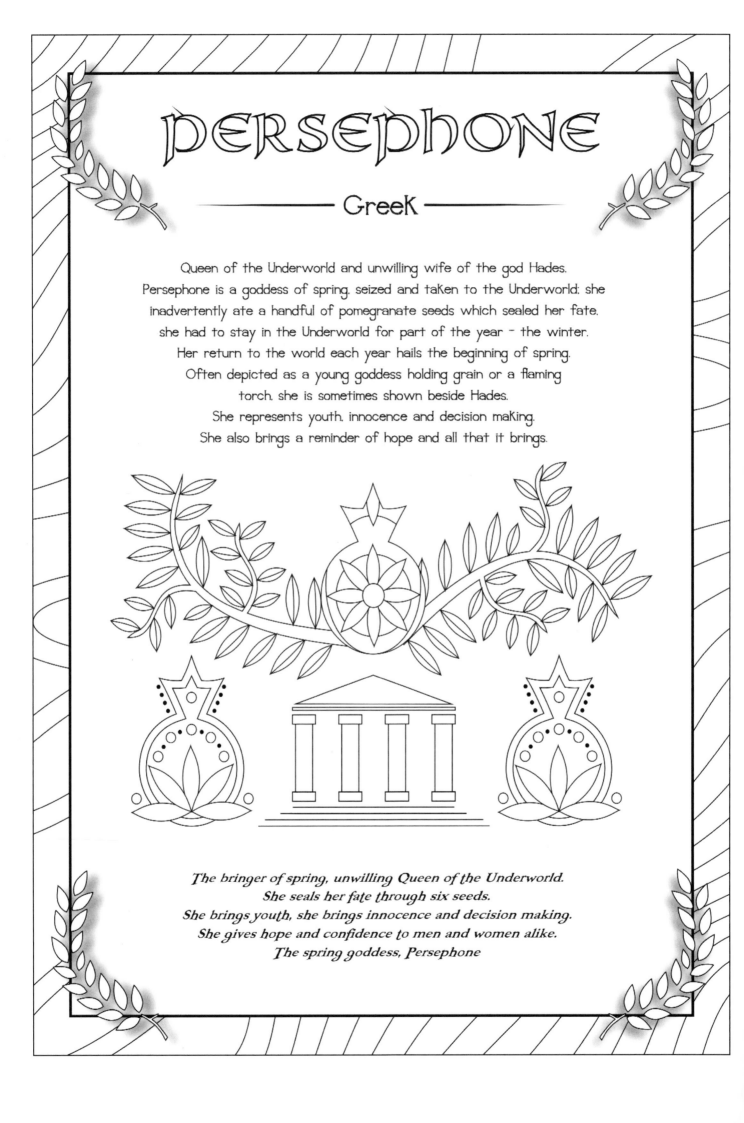

The bringer of spring, unwilling Queen of the Underworld.
She seals her fate through six seeds.
She brings youth, she brings innocence and decision making.
She gives hope and confidence to men and women alike.
The spring goddess, Persephone

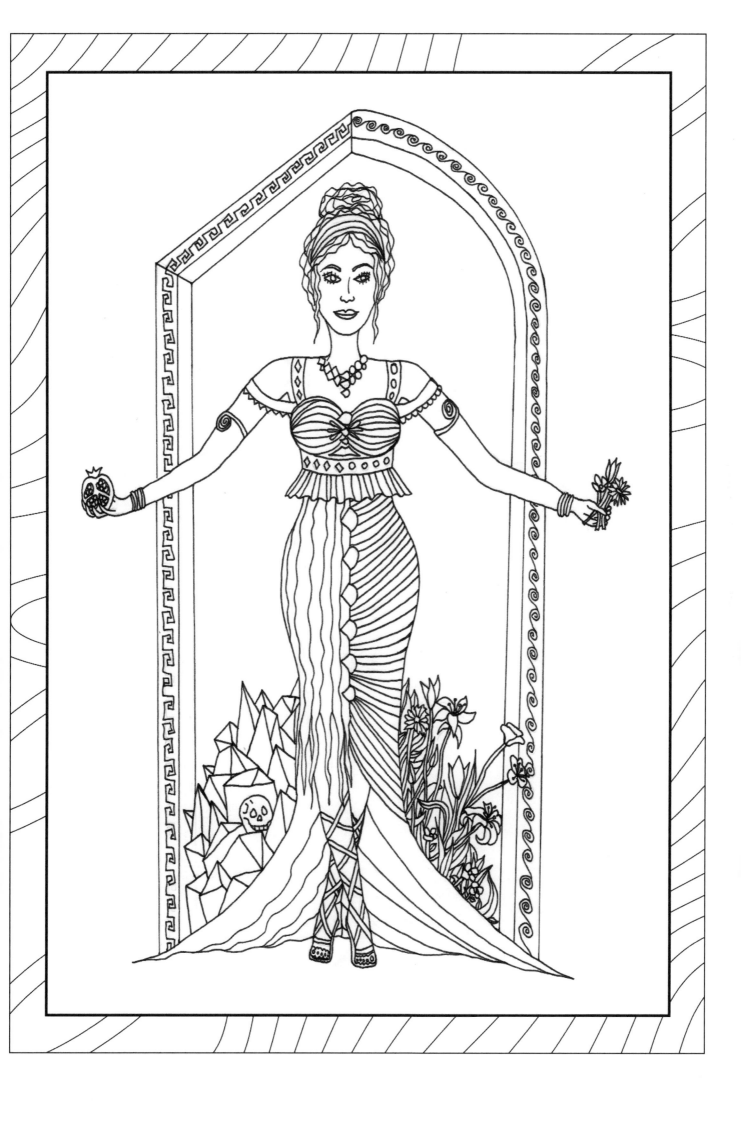

POSEIDON

— Greek —

Poseidon is a Greek god of the sea and protector
of all the creatures that live beneath it.
He drew lots with his brothers Zeus and Hades and won the position of Lord of the Sea.
To impress the goddess Demeter he wanted to create the most beautiful
animal in the world and after several attempts the horse came into being.
He carries a trident which he can use to cause earthquakes and shatter any object.
Poseidon is known to be greedy and quite argumentative, & can also be vengeful when insulted.

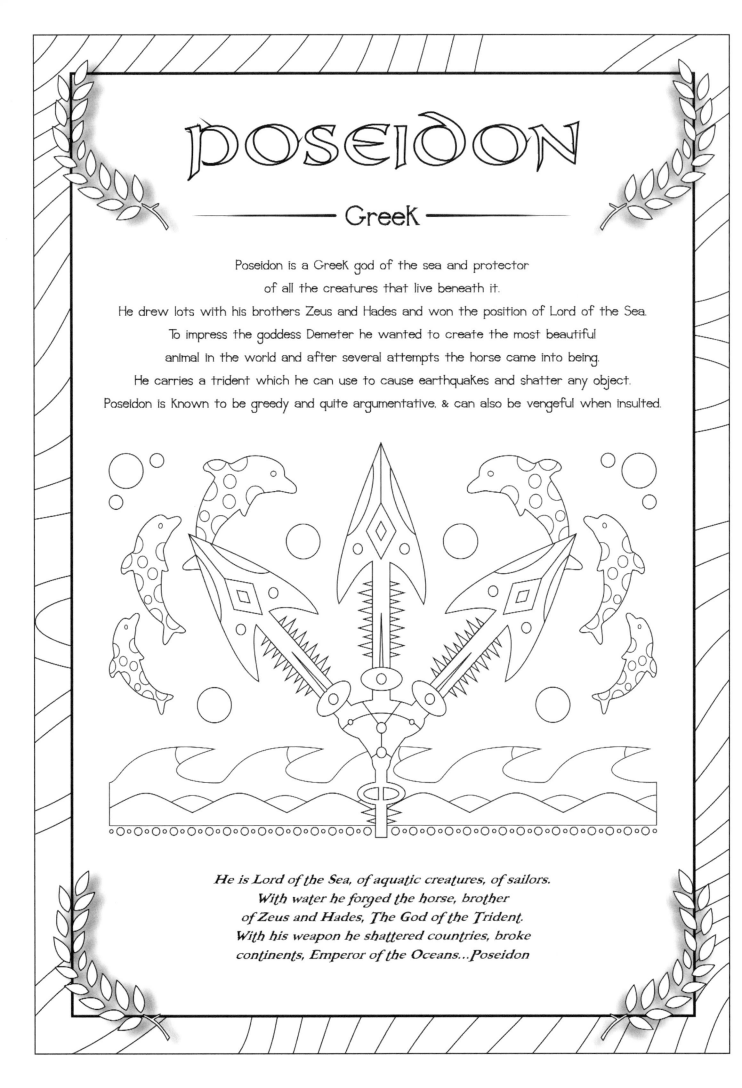

He is Lord of the Sea, of aquatic creatures, of sailors.
With water he forged the horse, brother
of Zeus and Hades, The God of the Trident.
With his weapon he shattered countries, broke
continents, Emperor of the Oceans...Poseidon

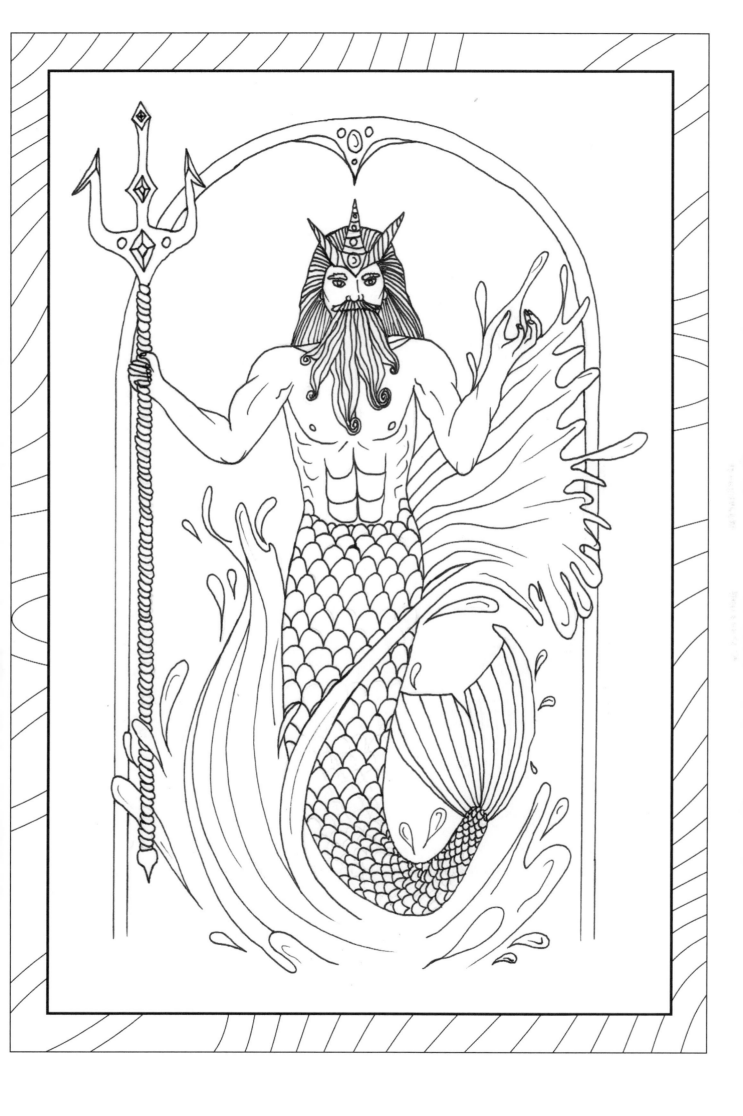

ZEUS

— Greek —

A god of the sky and the rain; he is
also ruler of the Olympian gods.
Zeus' weapon is a thunderbolt which he hurls at those that defy or upset him.
He rules the skies, the earth and all the natural phenomena therein.
He has a shield, the Aegis, with which he can create storms, tempests
and complete darkness. He is a god of time and the changing seasons.
As father of all men he looks after the well being of all mortals rewarding them
for truth, charity and fairness but punishing those that are cruel or evil.

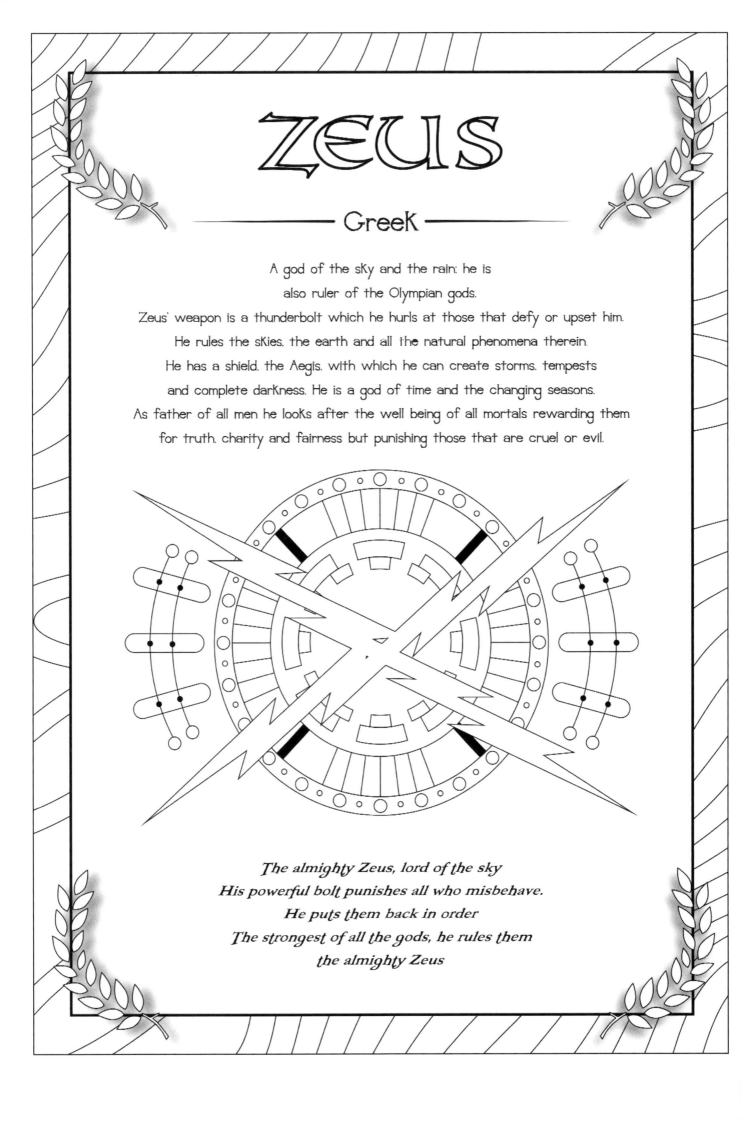

The almighty Zeus, lord of the sky
His powerful bolt punishes all who misbehave.
He puts them back in order
The strongest of all the gods, he rules them
the almighty Zeus

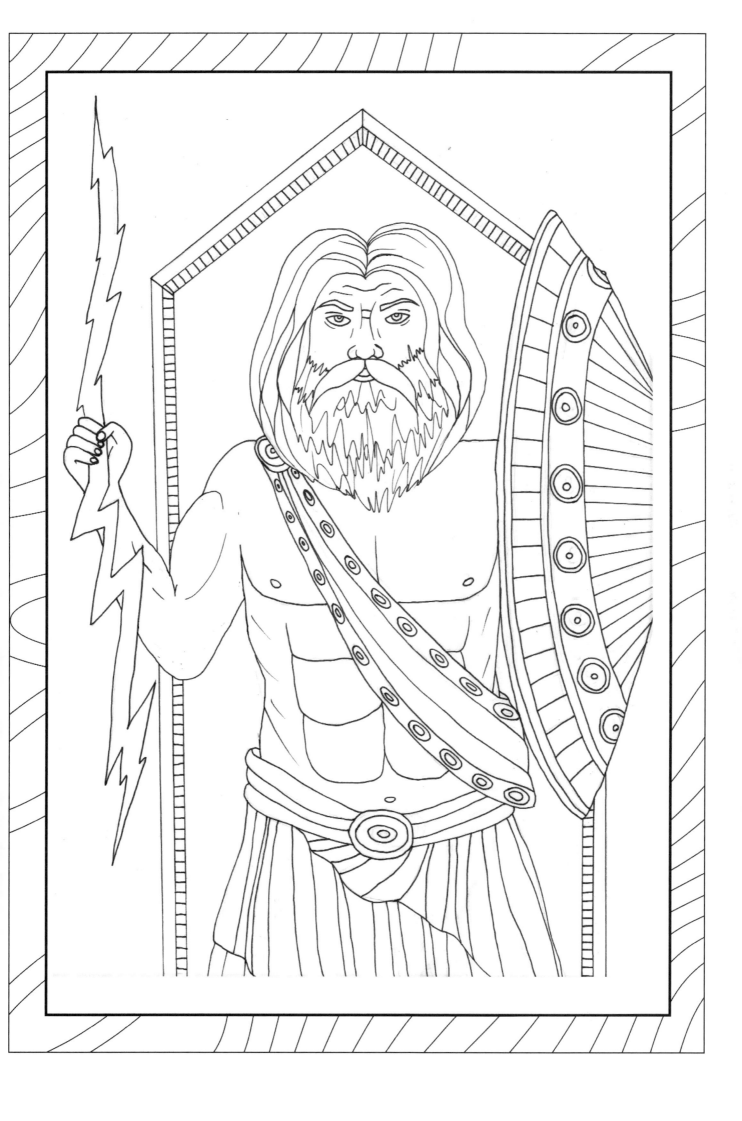

GANESHA

— Hindu —

Ganesha is the elephant headed god who creates the faith to remove all
obstacles and doubts. showing the spiritual side of everything.
He is Lord of good fortune. providing prosperity. fortune and success.
Ganesha is the Lord of beginnings but also places obstacles in
the pathway of those that need to be brought into check.
Generally depicted with four arms he holds his own
broken tusk in his right hand and a laddoo (Indian sweet) in his left.
He often holds an axe and a noose in his other hands.
Other images show him holding a water lily. musical
instruments and mace or a bowl of sweets.

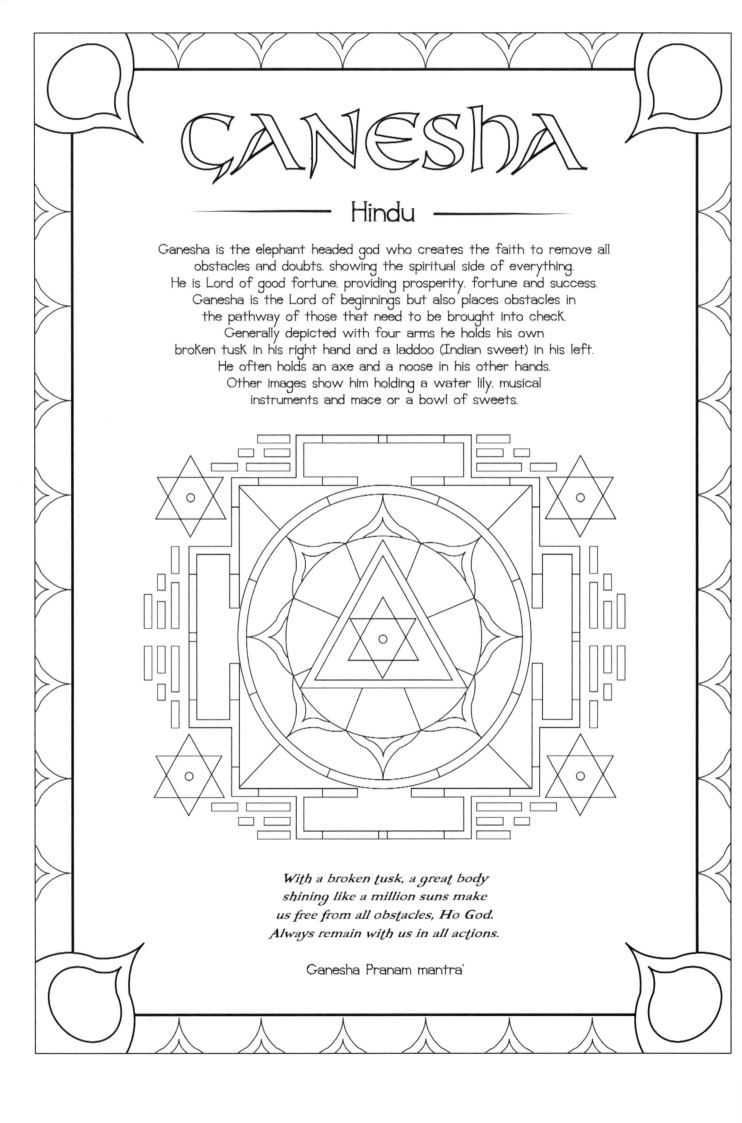

With a broken tusk, a great body
shining like a million suns make
us free from all obstacles, Ho God.
Always remain with us in all actions.

Ganesha Pranam mantra'

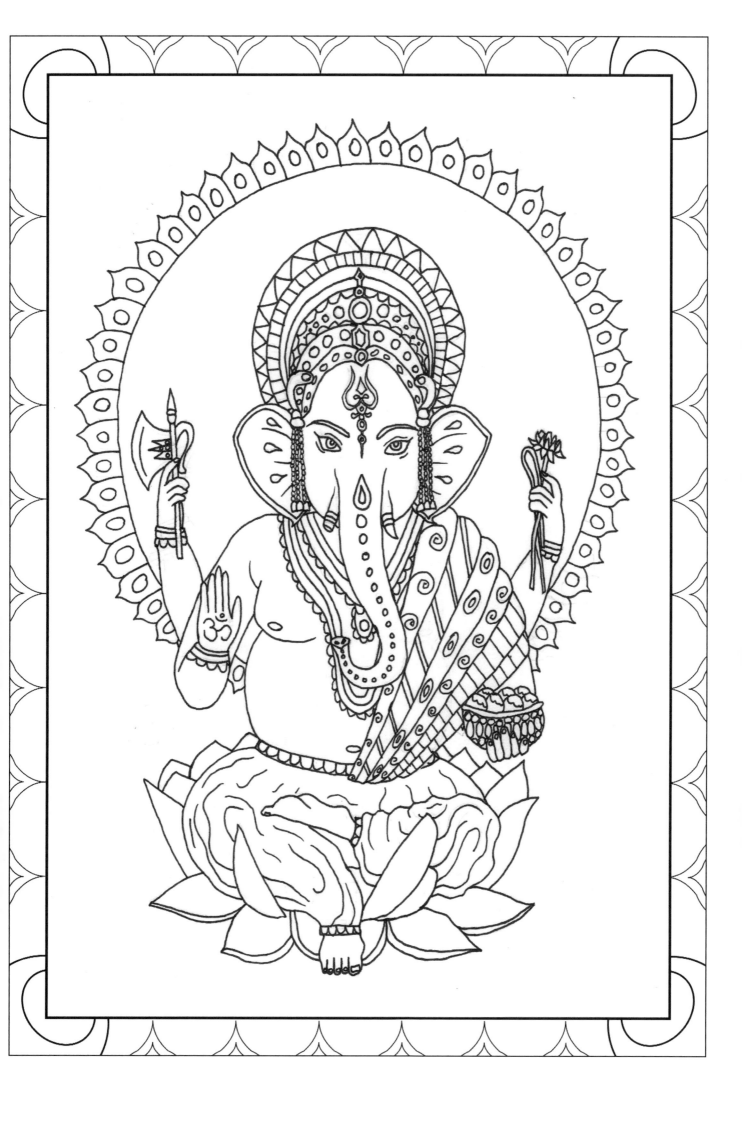

KALI

— Hindu —

Kali is a form of the Divine Mother. she dances on the field of
consciousness with wild abandon. She is the primal energy of spiritual freedom.
She is our darKness and shows us how to worK with it.
Kali also means 'time' as she is beyond time and a
goddess of the transformation that is death.
She is the energy of wisdom. Knowledge and intuition.
Usually depicted wearing a garland of sKulls and often with a sKirt
of dismembered arms she shows us that truth is
of the spirit not the flesh.
She holds a sword with a freshly severed head to
represent a great battle where she destroys the demon.
Her sKin is often shown as blacK or blue.

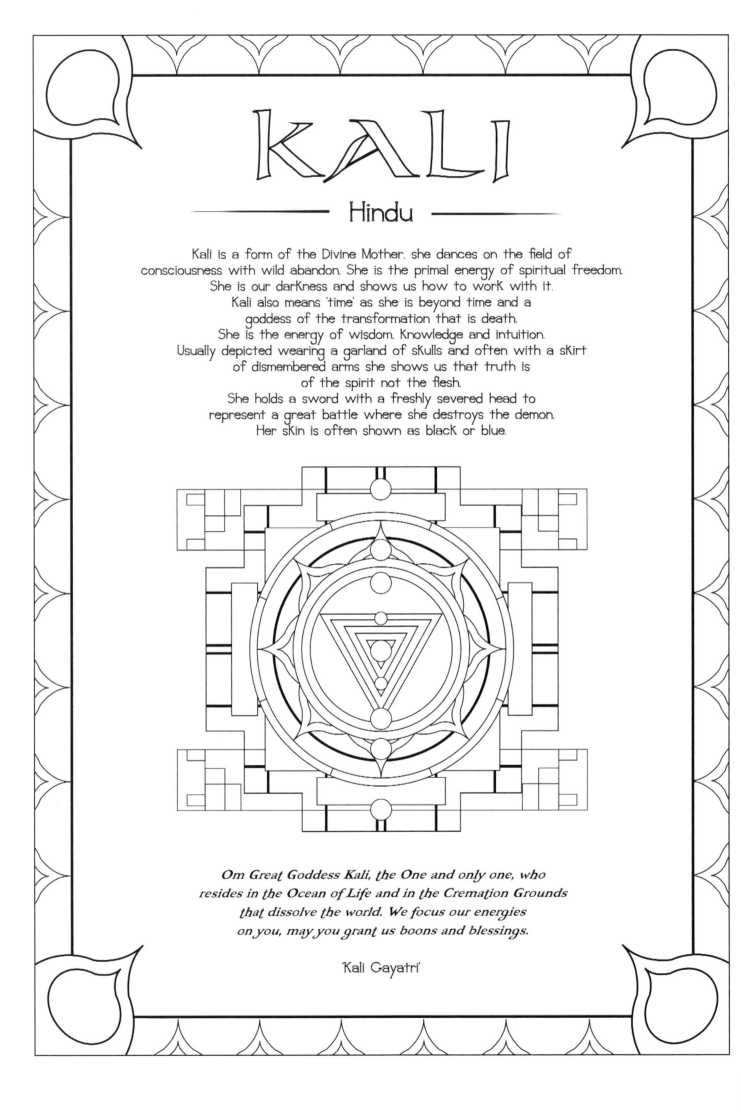

Om Great Goddess Kali, the One and only one, who
resides in the Ocean of Life and in the Cremation Grounds
that dissolve the world. We focus our energies
on you, may you grant us boons and blessings.

'Kali Gayatri'

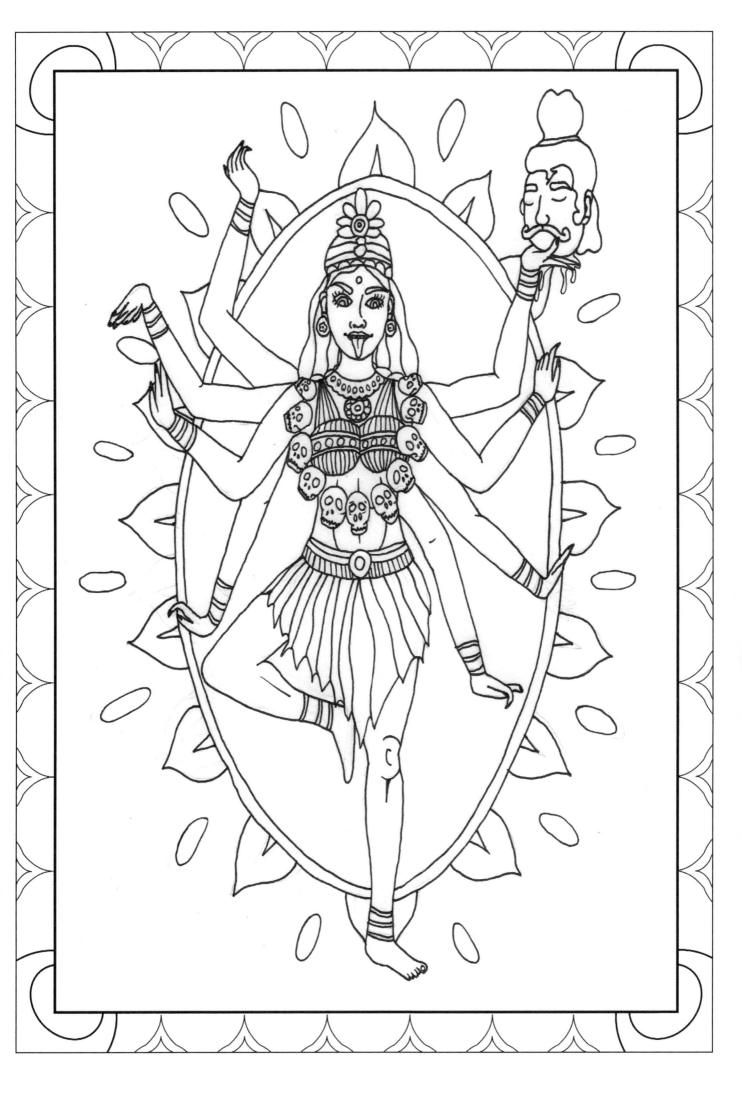

LAKSHMI

— Hindu —

Lakshmi is a goddess of fortune, power, luxury, beauty, wealth and fertility.
She can bring fulfilment and contentment of the material kind. Her sacred
name is 'Shri' and this is written on petitions and spoken before addressing
any revered individual. 'Om' is often associated with the mystical
things in life and 'shri' is the balance on the material side.
Her name is derived from the root word 'laksha' which means goal or objective.
Four of her arms represent the four ends of human life:
dharma (righteousness), Kama (genuine desires), artha (wealth)
and maksha (liberation from birth and death).
The front arms represent the activity of the physical world and the back
hands indicate the spiritual activities that lead to spiritual perfection.

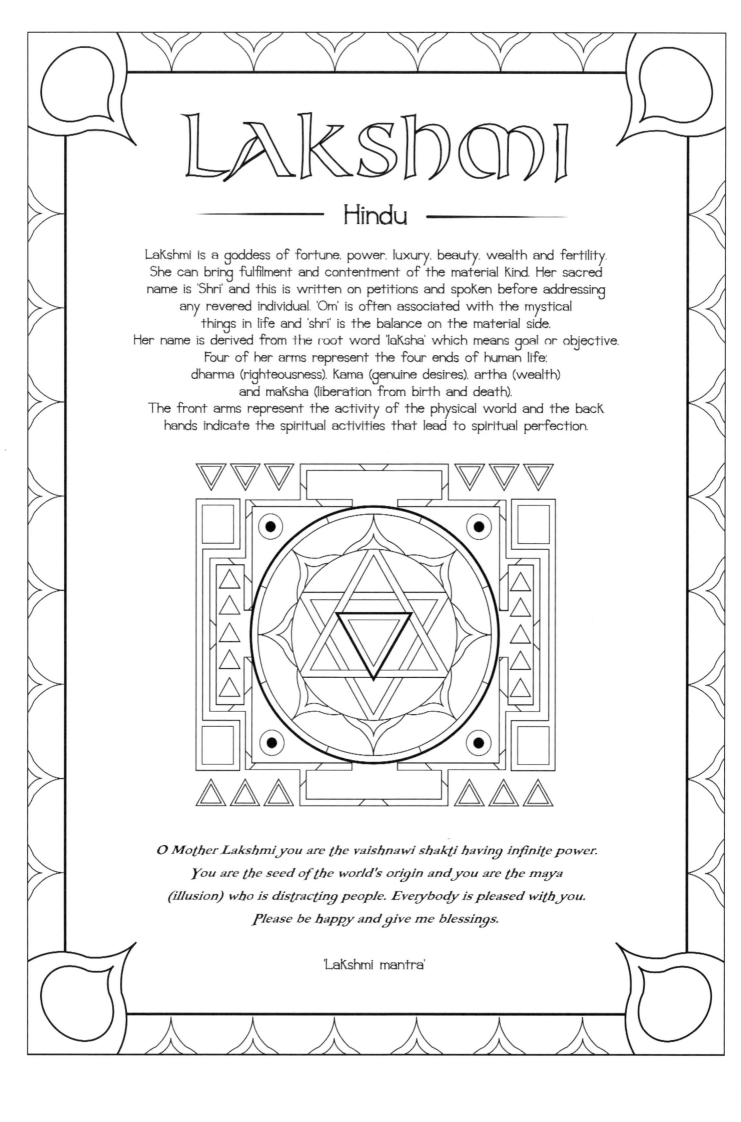

O Mother Lakshmi you are the vaishnawi shakti having infinite power.

You are the seed of the world's origin and you are the maya

(illusion) who is distracting people. Everybody is pleased with you.

Please be happy and give me blessings.

'Lakshmi mantra'

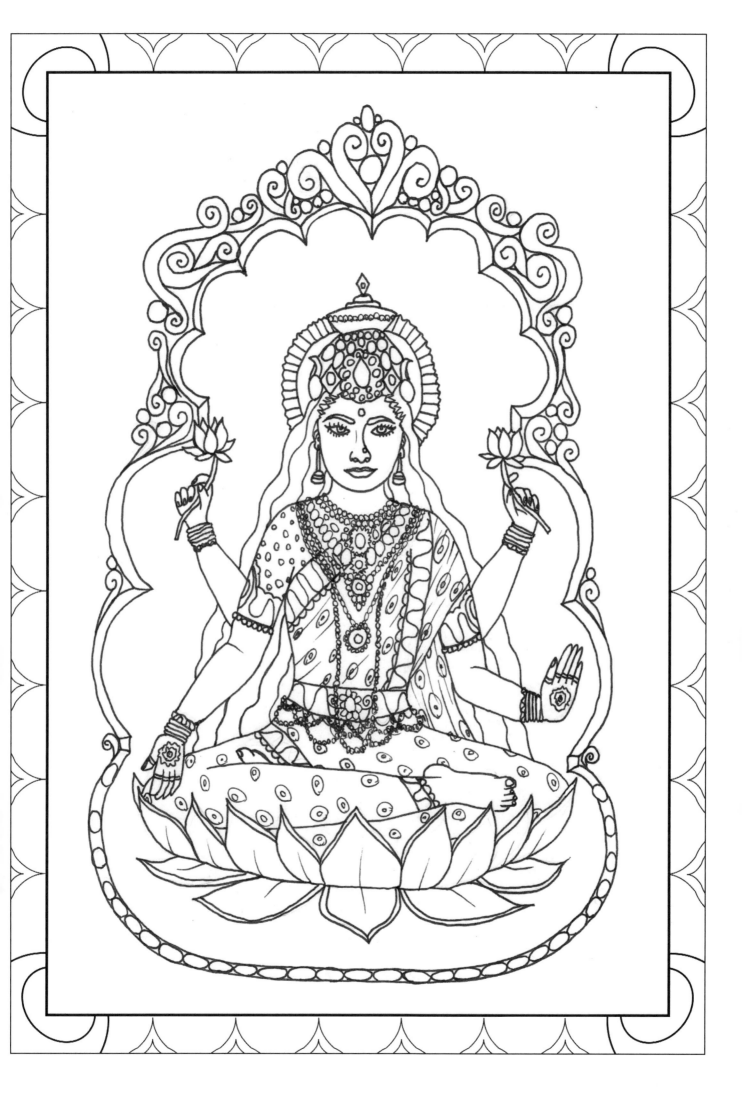

PARVATI

— Hindu —

A goddess of love and devotion, Parvati is one of the many
forms of Shakti. She is the feminine energy of the universe, bringing
skill, power, prowess and genius infusing the world with her magic.
She is an affirmation that there are no limits to what a woman can do
when she uses her spiritual energy to follow her dreams.
Her name means 'she who is of the mountains'. When shown beside the
god Shiva, Parvati has two arms, the right one holds a blue lotus and the
left hangs beside her. When depicted on her own she is Parvati Ma and
has four arms, two holding red and blue lotuses and the other two in the
mudra shapes varada and abhaya.

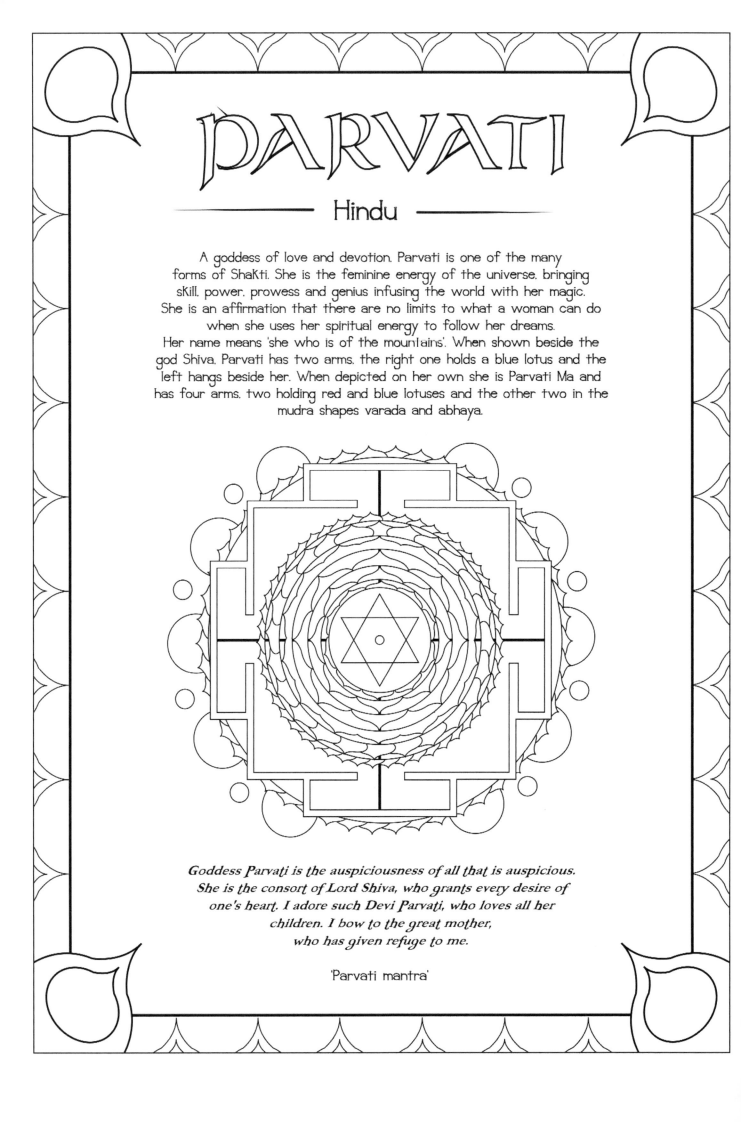

Goddess Parvati is the auspiciousness of all that is auspicious.
She is the consort of Lord Shiva, who grants every desire of
one's heart. I adore such Devi Parvati, who loves all her
children. I bow to the great mother,
who has given refuge to me.

'Parvati mantra'

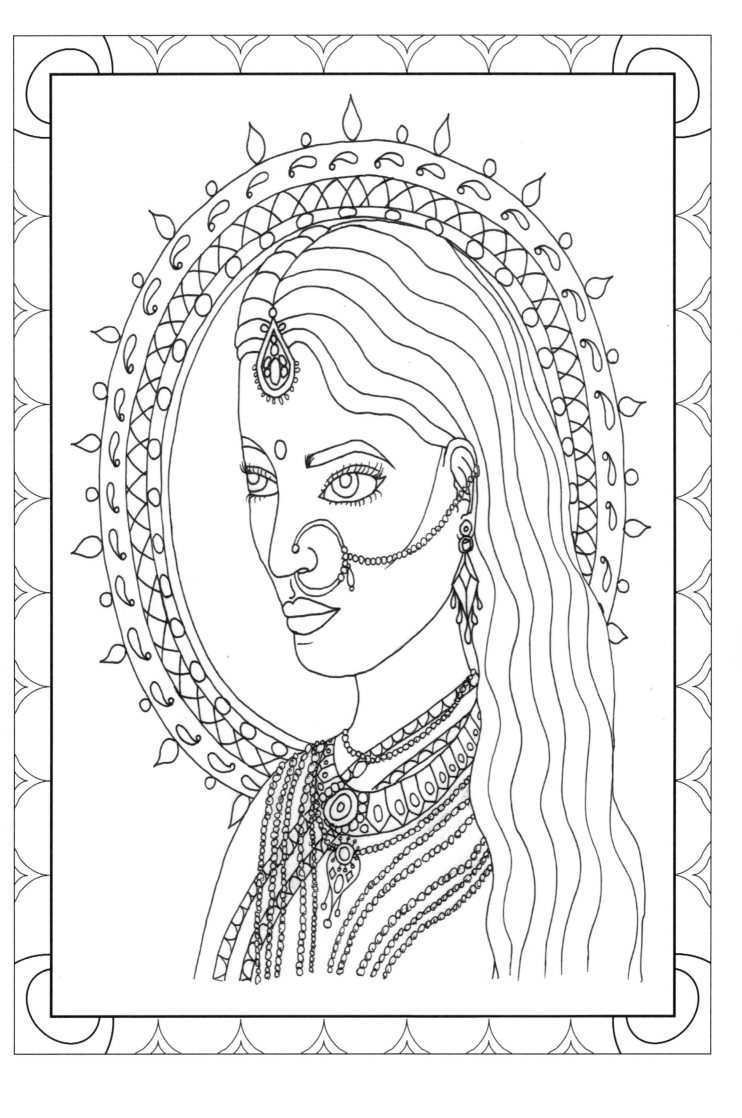

SARASWATI

— Hindu —

Saraswati is the Hindu goddess of Knowledge, music, learning, arts and science. Her name comes from 'saras' meaning flow and 'wati' meaning she who has flow. She is the mother of the Vedas and chants to her, called Saraswati Vandana often begin and end Vedic lessons. She is often depicted wearing a white saree seated on a white lotus or riding a white swan, white signifying purity and an immaculate mind. The white swan denotes an enquiring mind and the white lotus symbolising the search for light of Knowledge.
She plays a musical instrument, the vina which represents harmony of the mind and attitudes. Her four arms correspond to the four aspects of the human personality in learning: mind, intellect, alertness and ego but the four arms also represent the four Vedas, the sacred books.

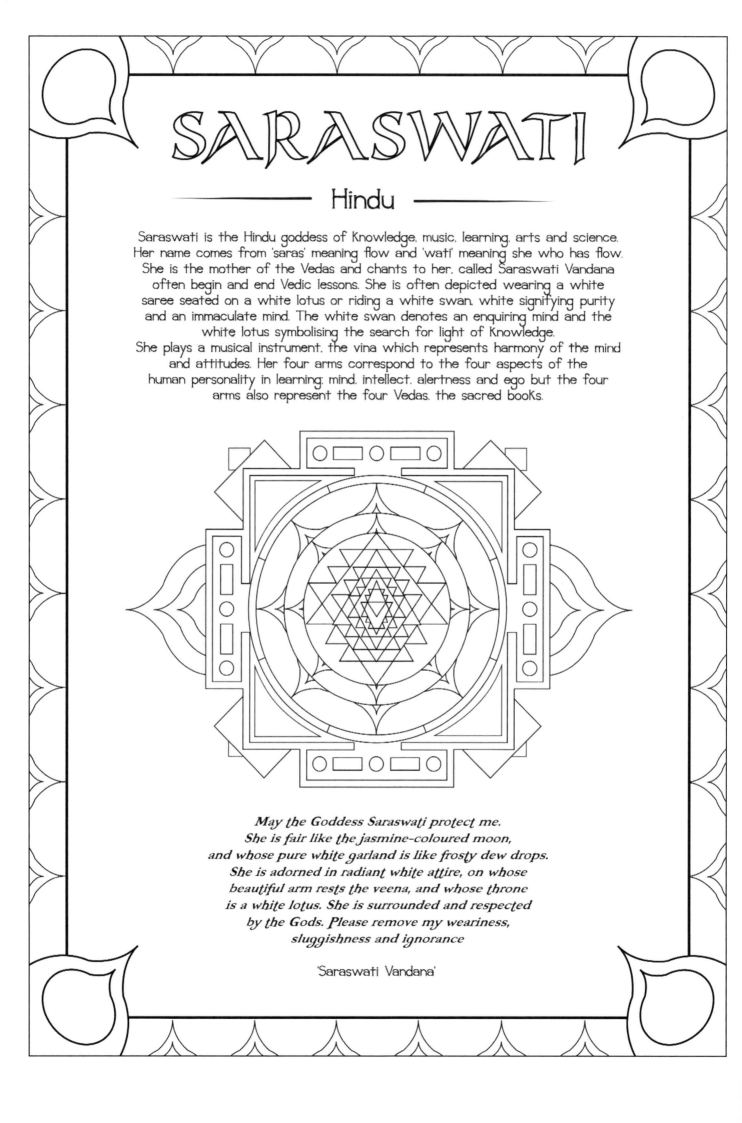

May the Goddess Saraswati protect me.
She is fair like the jasmine-coloured moon,
and whose pure white garland is like frosty dew drops.
She is adorned in radiant white attire, on whose
beautiful arm rests the veena, and whose throne
is a white lotus. She is surrounded and respected
by the Gods. Please remove my weariness,
sluggishness and ignorance

'Saraswati Vandana'

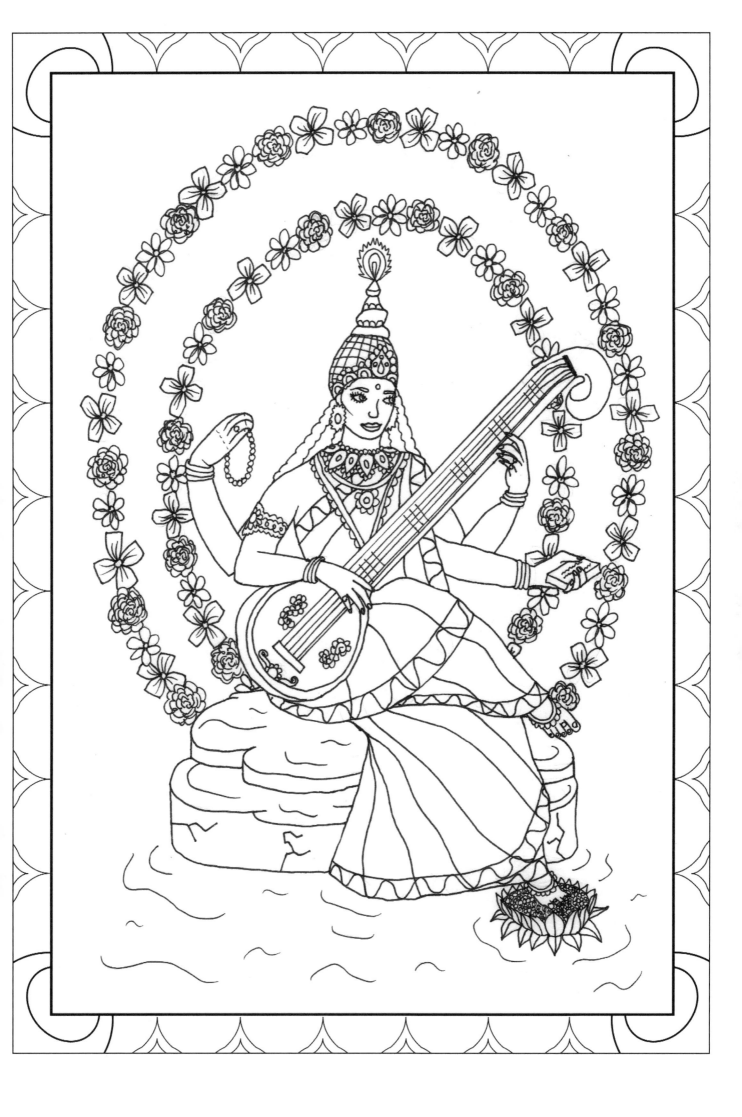

ShAKTI

— Hindu —

Shakti is the divine force, manifesting to destroy demonic forces and restore balance.
Every god in Hinduism has his 'Shakti' and without that energy they have no power.
Shakti is the mother goddess, the source of all, the universal
principle of energy, power or creativity.
Shakti brings protection, banishing and communication,
along with supreme feminine power.
She is an active loving force for change and manifests intelligence,
instinct, willpower, energy, action and magic. Her name translates as
'to be able' meaning sacred force or empowerment.

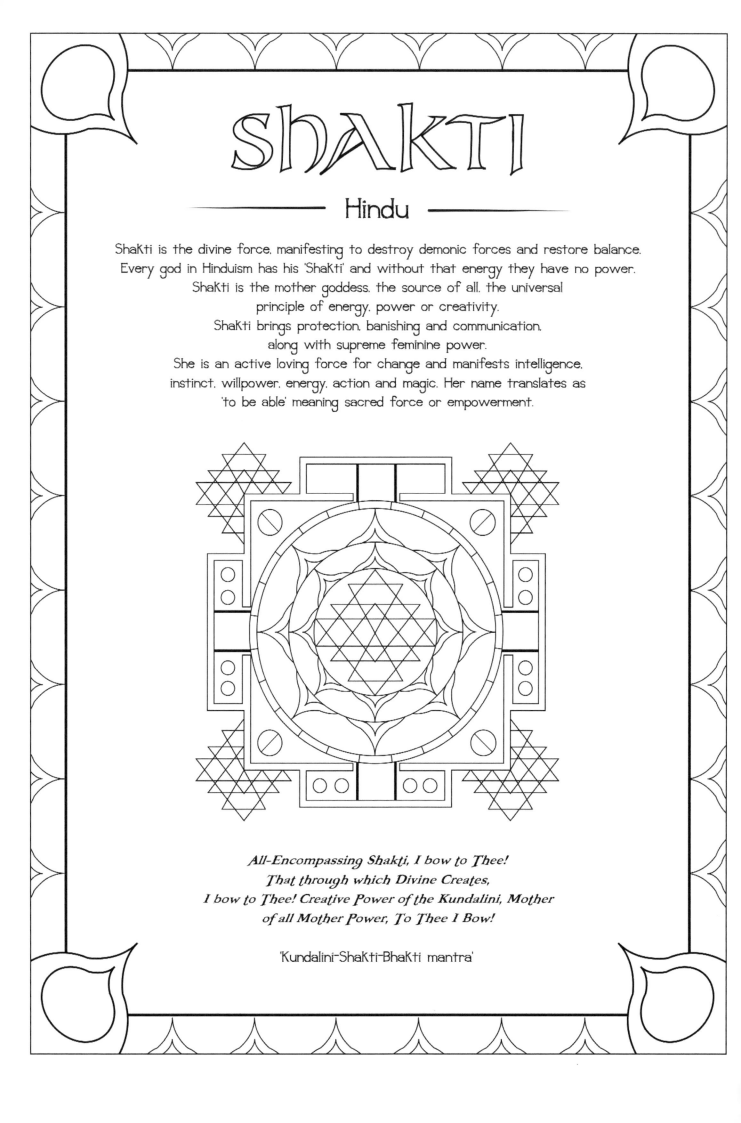

All-Encompassing Shakti, I bow to Thee!
That through which Divine Creates,
I bow to Thee! Creative Power of the Kundalini, Mother
of all Mother Power, To Thee I Bow!

'Kundalini-Shakti-Bhakti mantra'

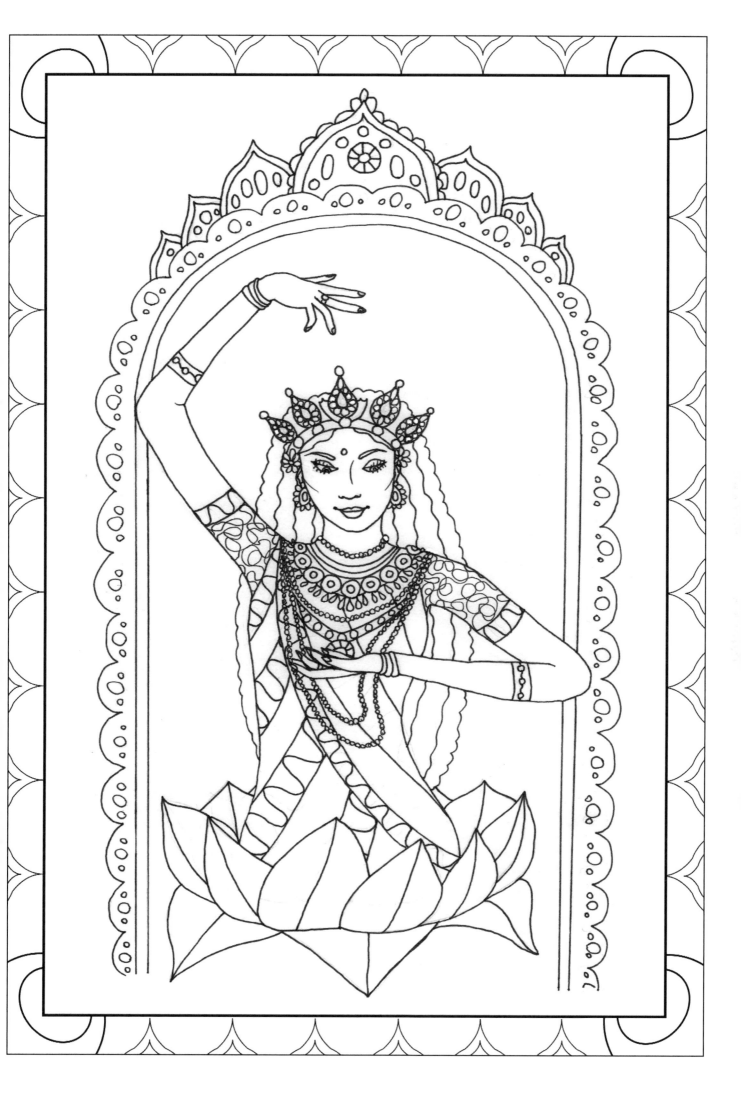

Shiva

— Hindu —

Shiva, whose name translates as 'auspicious one', is the destroyer and the restorer,
the symbol of sensuality, a benevolent herder of souls and also a wrathful avenger.
Often depicted with a snake coiled around his arms and neck the
snake symbolises the power he has over deadly creatures.
Shiva holds a trident which represents the trinity of Brahma, Shiva and Vishnu but
also the qualities of creation, preservation and destruction. As the destroyer
Shiva is dark and terrible and shown with serpents and a crown of skulls.
The skull represents the cycle of life, death and rebirth.
His guardian is Nandi the white bull who is a symbol for sexual energy and fertility.
Shiva often wears a crescent moon crown which could be a symbol
of Nandi, fertility or Kama the goddess of nightly love.

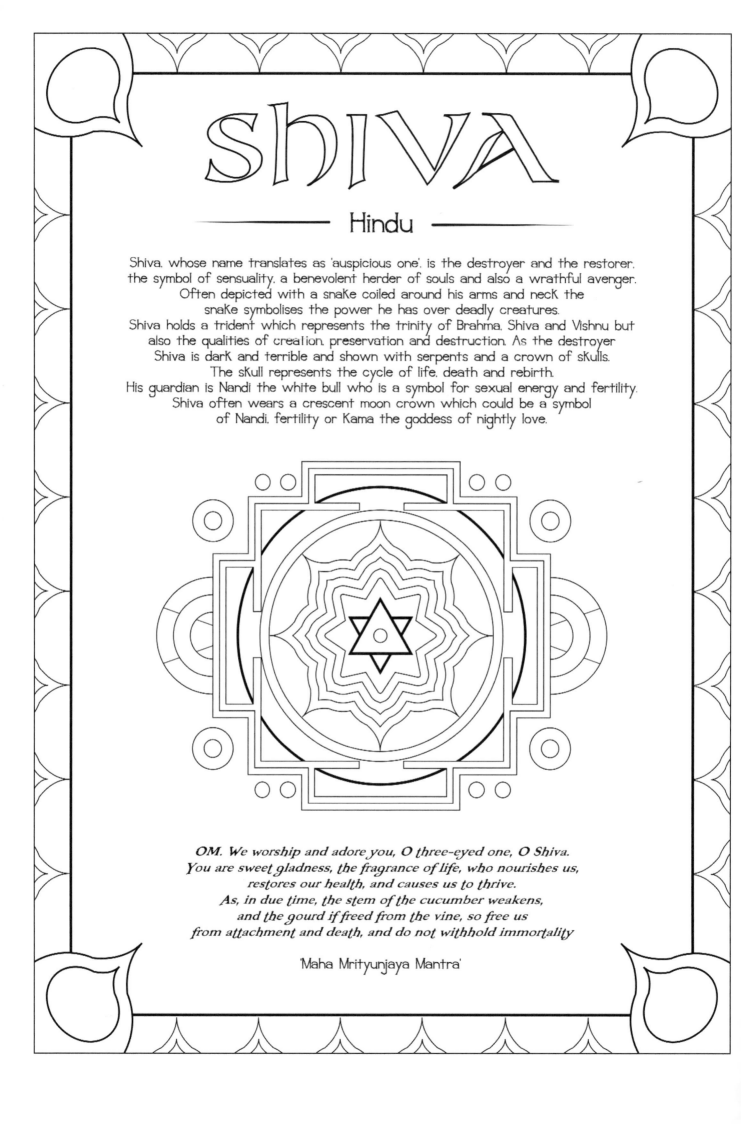

OM. We worship and adore you, O three-eyed one, O Shiva.
You are sweet gladness, the fragrance of life, who nourishes us,
restores our health, and causes us to thrive.
As, in due time, the stem of the cucumber weakens,
and the gourd if freed from the vine, so free us
from attachment and death, and do not withhold immortality

'Maha Mrityunjaya Mantra'

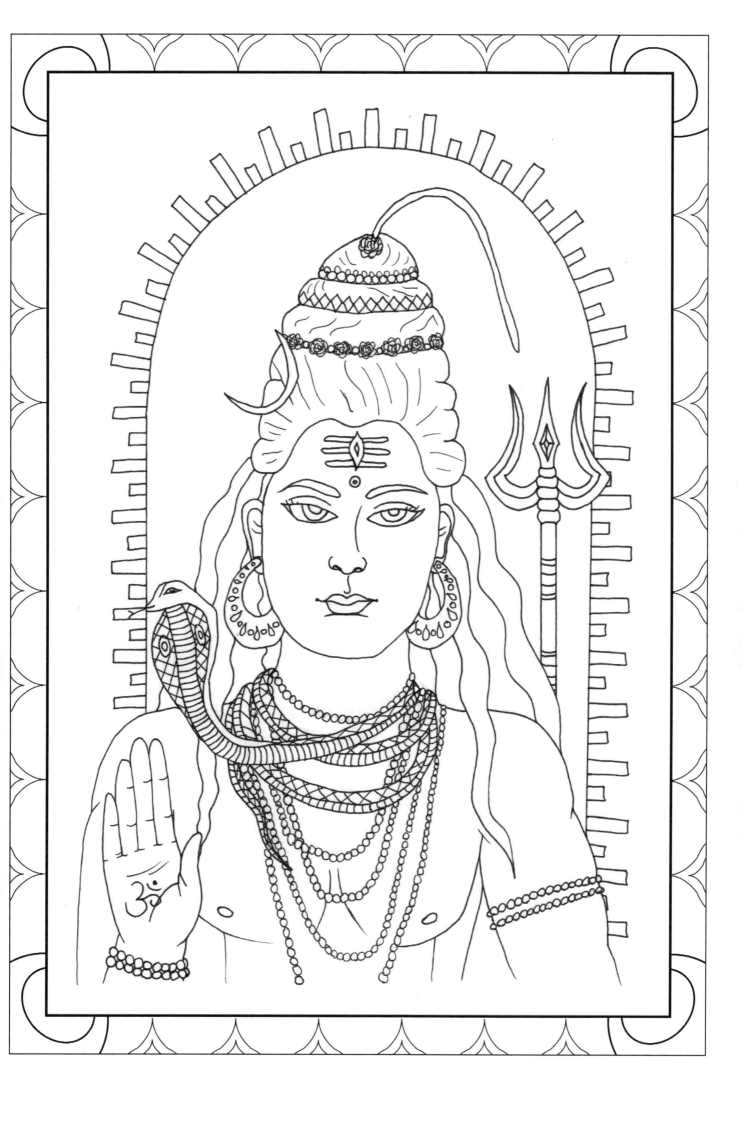

VISHNU

— Hindu —

Vishnu is the preserver and protector of creation and is the embodiment of
mercy, goodness, peace, the self and all pervading power that
preserves the universe and maintains the cosmic order.
In fact his name translates as 'all-pervading'. He has ten avatars (incarnations)
which appear on earth when there is disorder in the world.
Vishnu is the Supreme Lord and is usually depicted with four arms which
hold dominion over the four directions of space and the four stages of human
life: the quest for Knowledge, family life, retreat into the forest and
renunciation, they also represent the four aims of life: duty and virtue, material
goods/wealth/success, pleasure/sexuality/enjoyment and liberation.
He often holds a conch shell, discus, lotus and mace.

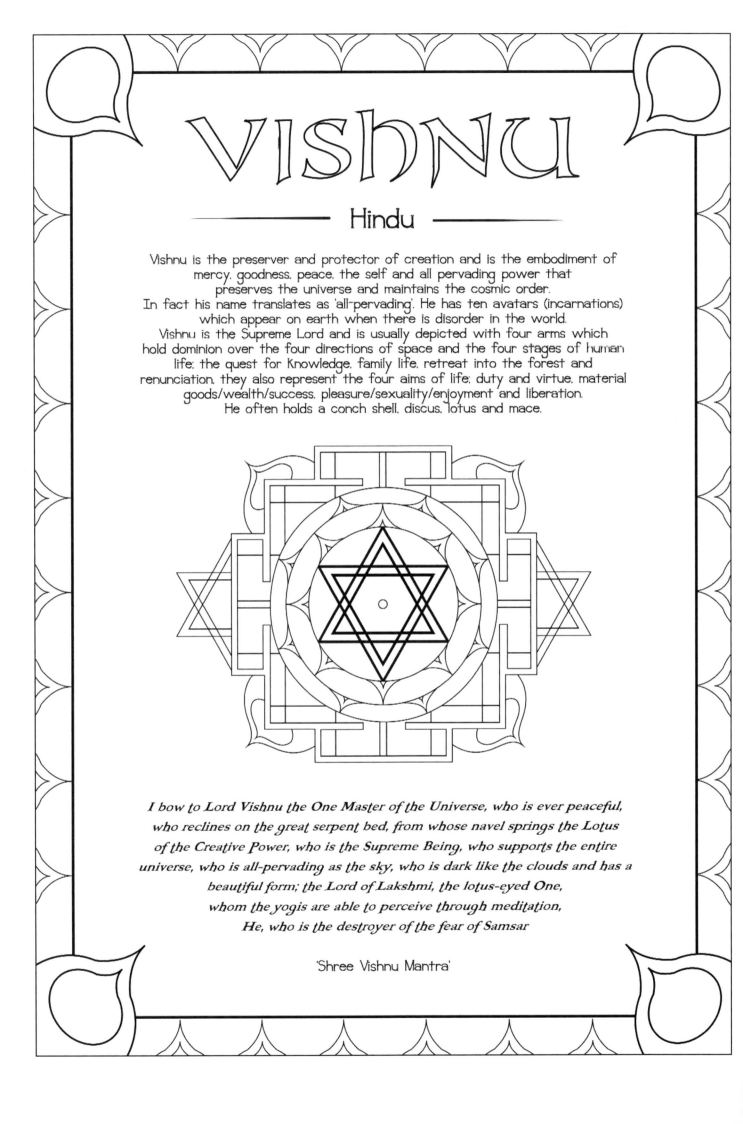

I bow to Lord Vishnu the One Master of the Universe, who is ever peaceful,

who reclines on the great serpent bed, from whose navel springs the Lotus

of the Creative Power, who is the Supreme Being, who supports the entire

universe, who is all-pervading as the sky, who is dark like the clouds and has a

beautiful form; the Lord of Lakshmi, the lotus-eyed One,

whom the yogis are able to perceive through meditation,

He, who is the destroyer of the fear of Samsar

'Shree Vishnu Mantra'

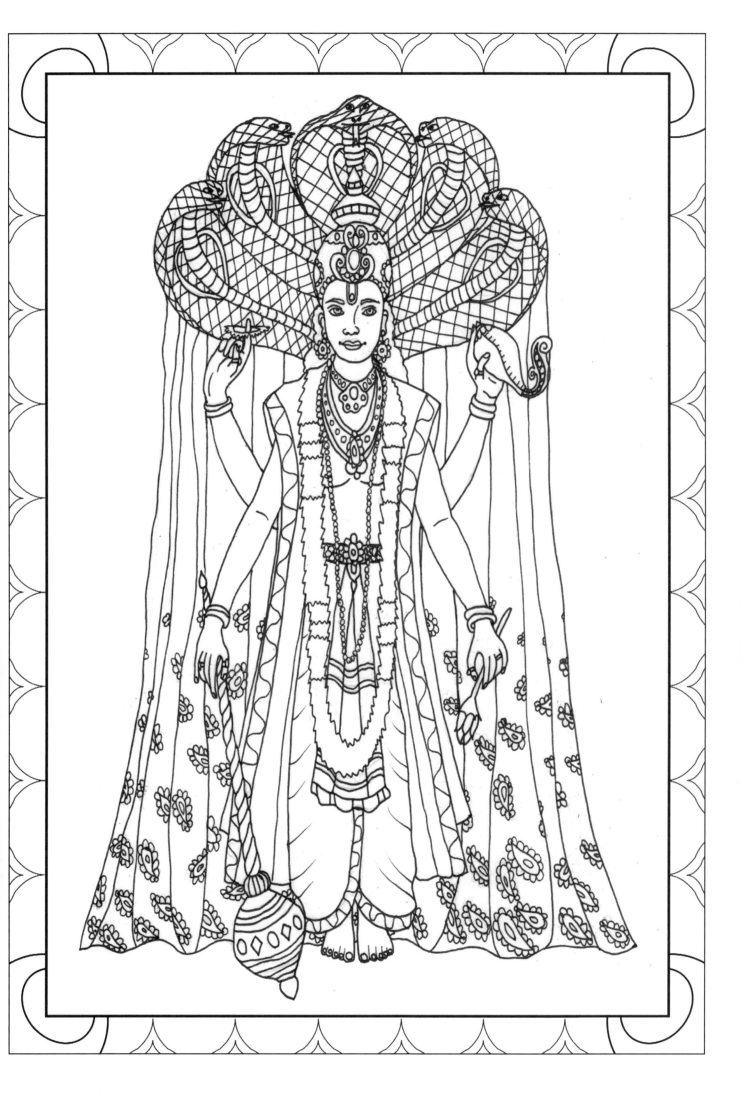

FREYA

— Norse —

Norse goddess of love and war Freya is a maiden mistress and
described as one of the most beautiful goddesses.
No man can resist her, god or mortal. She is called upon for
happiness in love and family relations as well as sex and sensuality.
As Queen of the ValKyries she gathers the souls of the dead warriors.
Mistress of cats she is thought to be the inspiration for all poetry. Her sacred day is Friday.

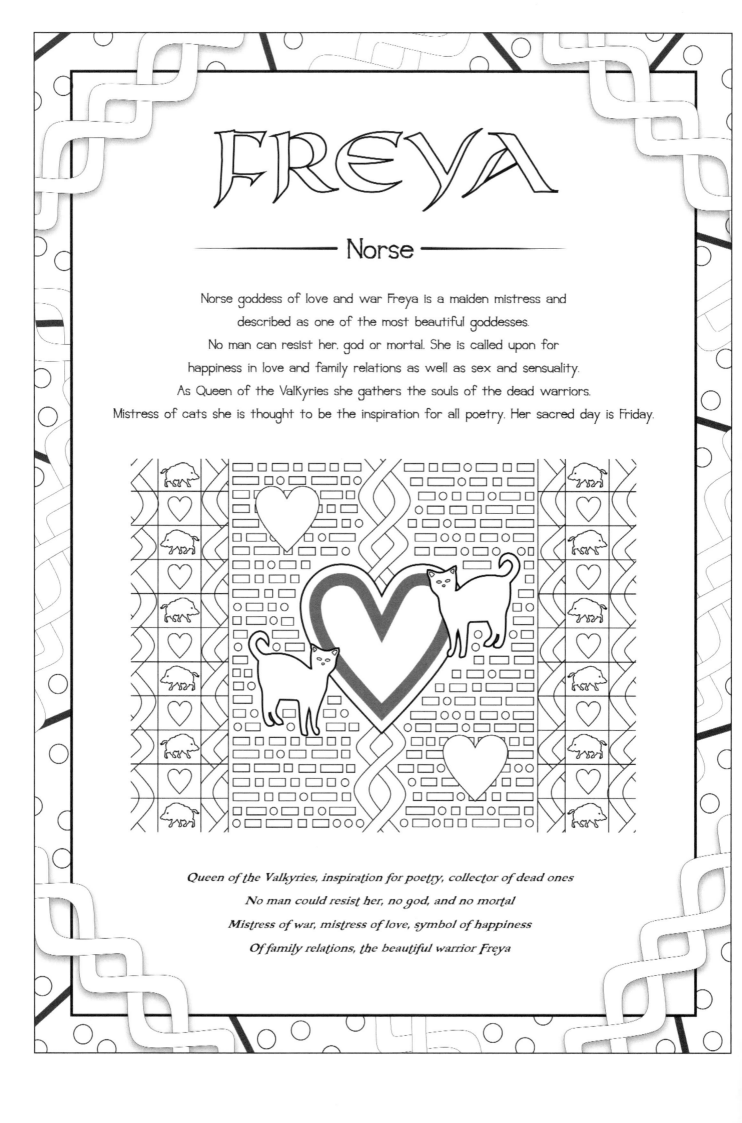

Queen of the Valkyries, inspiration for poetry, collector of dead ones
No man could resist her, no god, and no mortal
Mistress of war, mistress of love, symbol of happiness
Of family relations, the beautiful warrior Freya

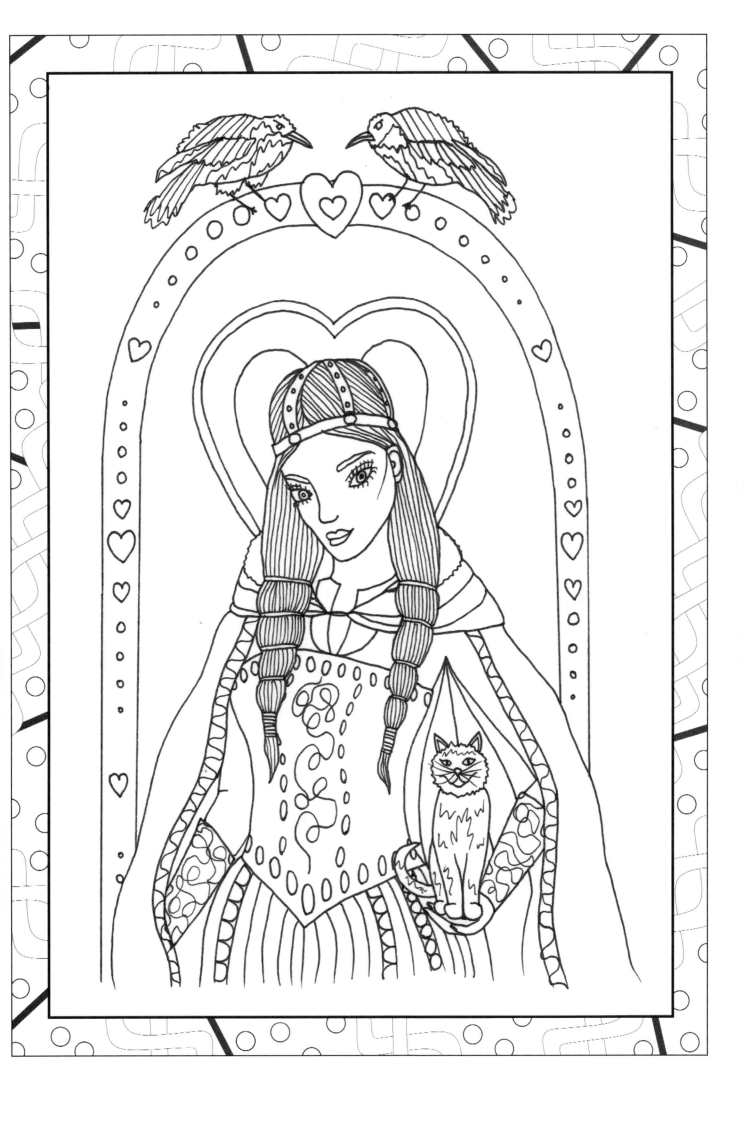

HEIMDALL

— Norse —

Heimdall is one of the Aesir gods and guardian of the gods' residence Asgard.

He lives in a fortress on top of Bifrost, the rainbow bridge that leads to Asgard.

His eyesight is amazing and he can see for hundreds of miles,

regardless of whether it is day or night.

His hearing is also beyond excellent and Heimdall is said to be able to hear the grass

as it grows. If he hears or sees intruders he sounds the Gjallarhorn as a warning.

Heimdall is a son of Odin and has an astounding nine mothers.

Guardian of human kind, protector of Asgard
Heimdall bears hearing so acute he can hear grass growing
And sight so keen he can see all day and night
He warns the gods of enemies with his mighty horn
Oh guardian, Heimdall

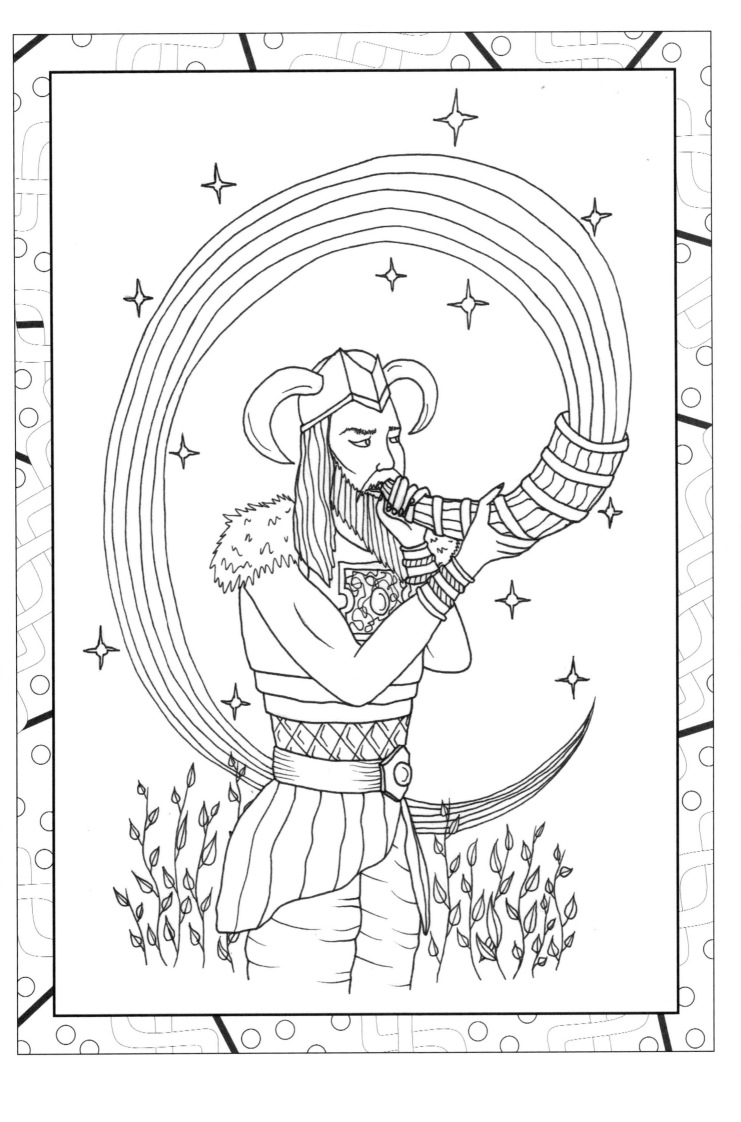

hel

— Norse —

Daughter of the Norse god Loki. Hel is ruler of the Underworld
and Queen of the dead, those that were not heroes or warriors.
She controls the souls of the wicked and those that die of old age or sickness.
She rules the underground Kingdom of Helheim as the dark hag that walks the
line between life and death. She is usually depicted as being half alive and half dead.

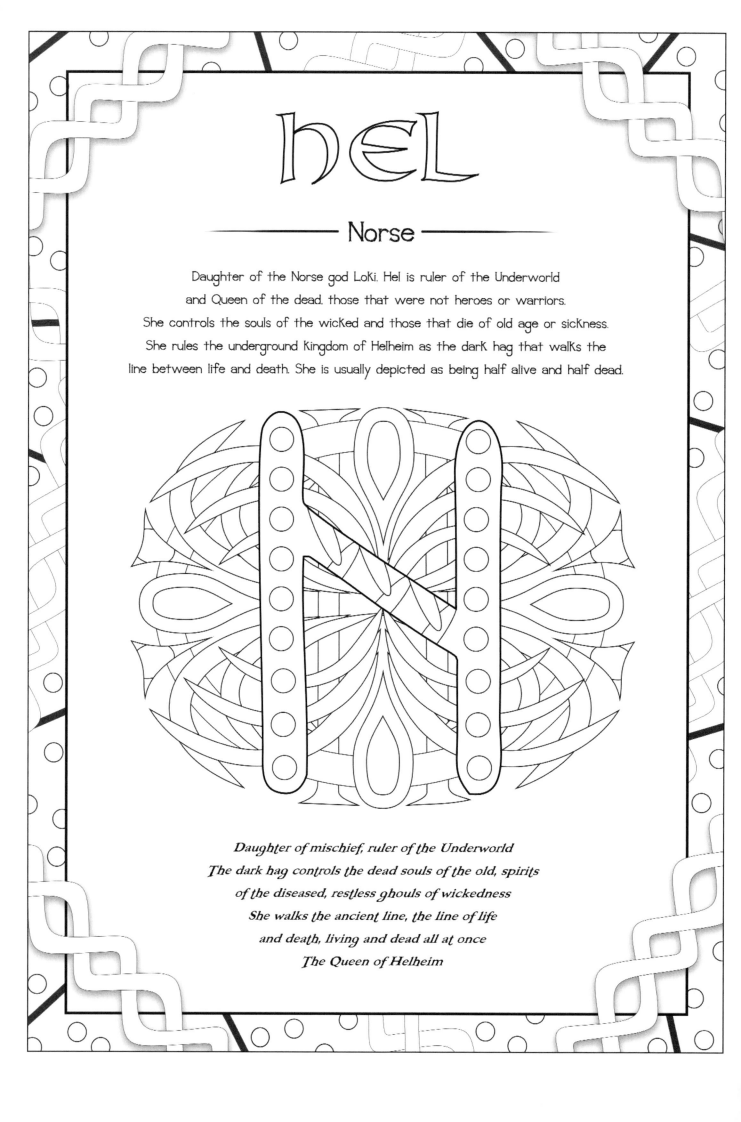

Daughter of mischief, ruler of the Underworld
The dark hag controls the dead souls of the old, spirits
of the diseased, restless ghouls of wickedness
She walks the ancient line, the line of life
and death, living and dead all at once
The Queen of Helheim

LOKI

— Norse —

Son of two giants and blood brother to Odin, Loki is the God of
mischief, trickery and lies. He is an absolute charmer who cares
little for others, he is sly and sometimes even malevolent.
He is an accomplished shape shifter often turning himself into a horse, fish or bird.
He fathered many children, some of them believed to be monsters or beasts.
He has no loyalty, helping either the gods or the giants
depending on which pleases him most at the time.

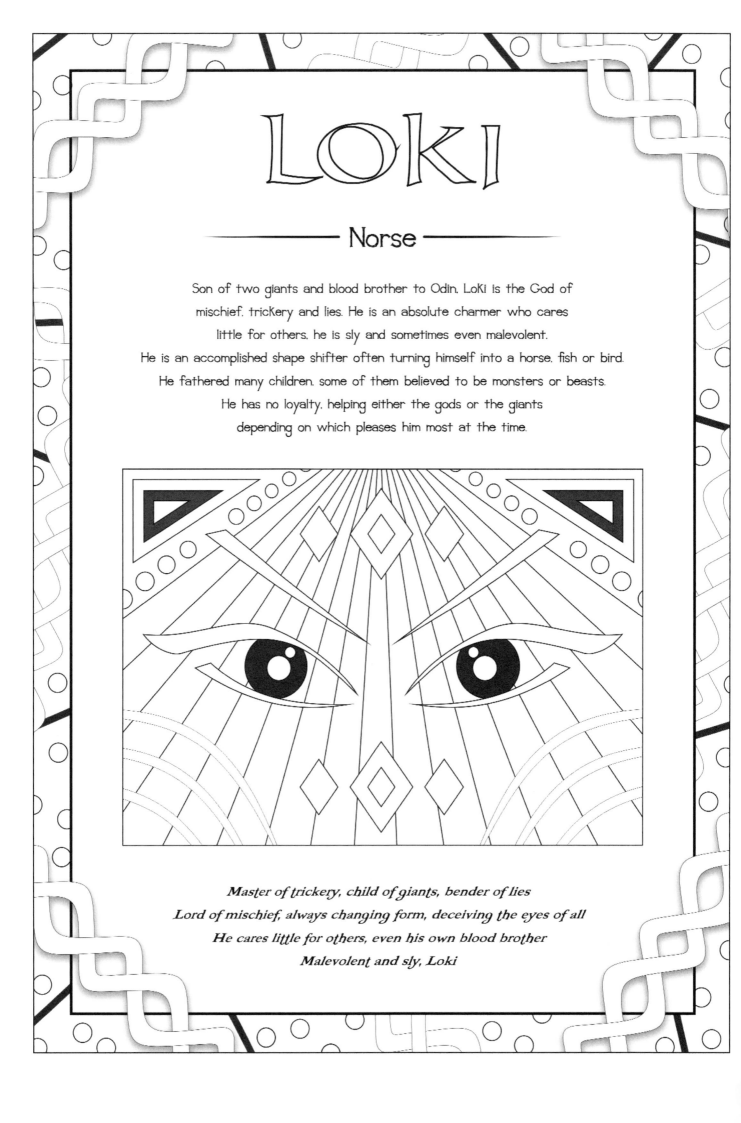

Master of trickery, child of giants, bender of lies
Lord of mischief, always changing form, deceiving the eyes of all
He cares little for others, even his own blood brother
Malevolent and sly, Loki

ODIN

— Norse —

Chief god of the Norse pantheon and the foremost of the Aesir. Odin is the 'all father'
or father of the gods. He is a god of war and death but also of poetry and wisdom.
He hung from the world tree for nine days where he learned songs and the magic of runes.
From his throne in Asgard he rules the nine worlds with messages
brought to him by his two ravens Huginn and Muninn.
He can also be found in Valhalla where slain warriors are taken.
He is often accompanied by his two wolves Freki and Geri.
Odin has one bright eye; the other was given in a magical trade for immense wisdom.

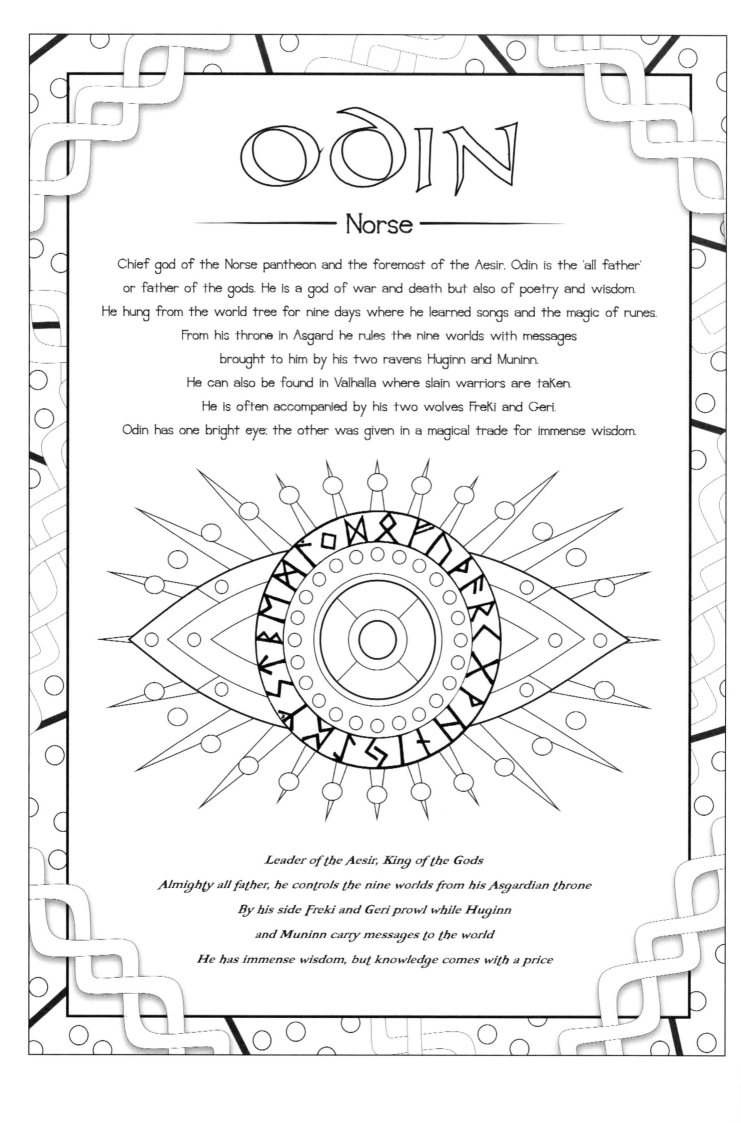

Leader of the Aesir, King of the Gods

Almighty all father, he controls the nine worlds from his Asgardian throne

By his side Freki and Geri prowl while Huginn

and Muninn carry messages to the world

He has immense wisdom, but knowledge comes with a price

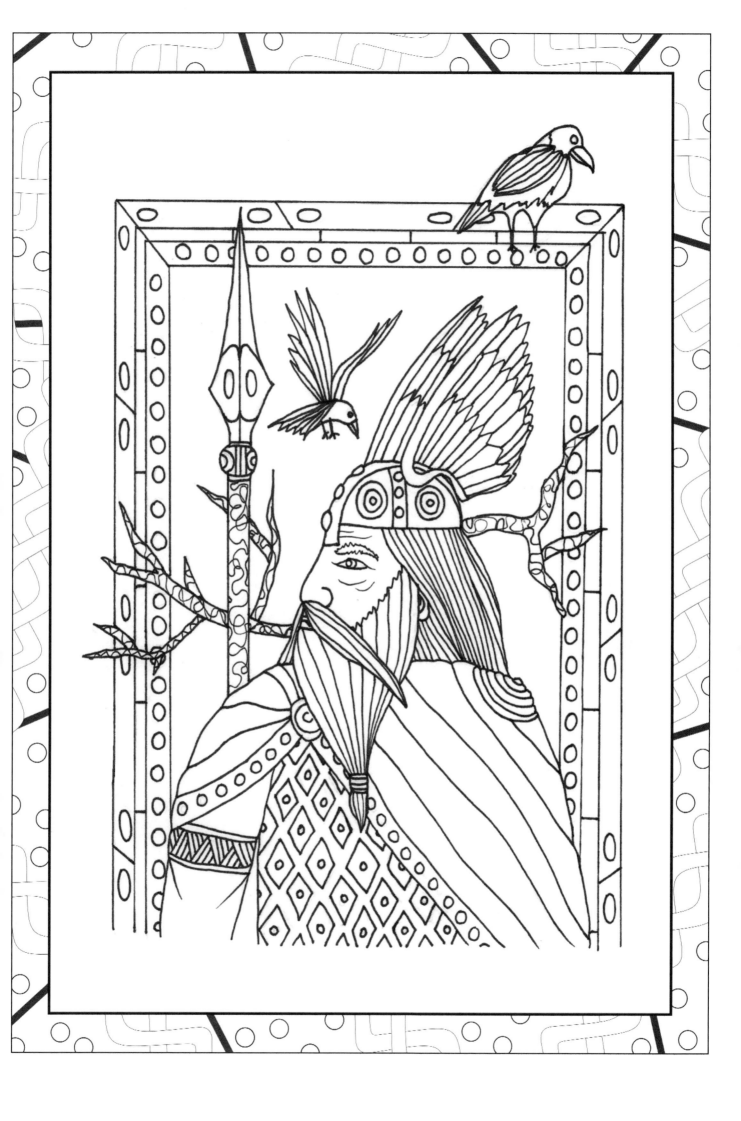

SKAÐI

— Norse —

Skaði is a giant goddess whose name translates as 'harm' or 'shadow'.
She lives in the highest mountains where the snow is always thick and the wind chills.
Skaði is a huntress and is often depicted with her bow and arrow, snowshoes and skis.
She was married to the god Njord but he didn't like the cold landscape of the mountains
and Skaði didn't like the light and noise of his home by the sea, so their marriage
was short lived. She is a winter goddess with perhaps a touch of benevolence.

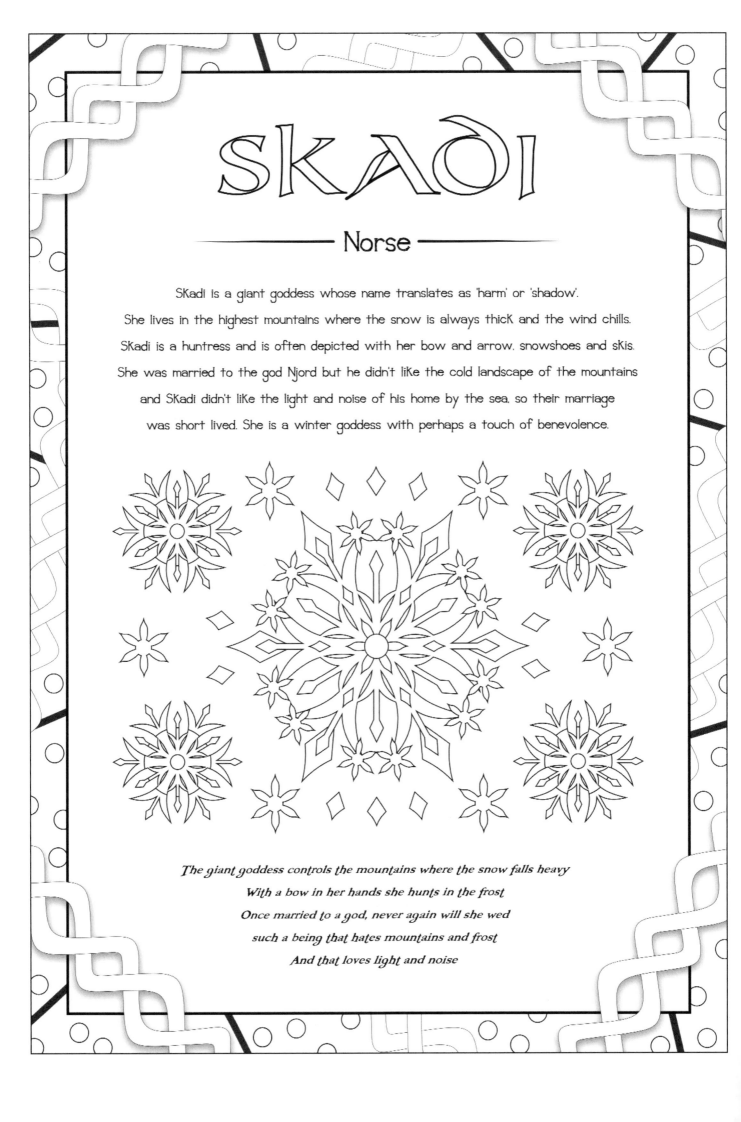

The giant goddess controls the mountains where the snow falls heavy
With a bow in her hands she hunts in the frost
Once married to a god, never again will she wed
such a being that hates mountains and frost
And that loves light and noise

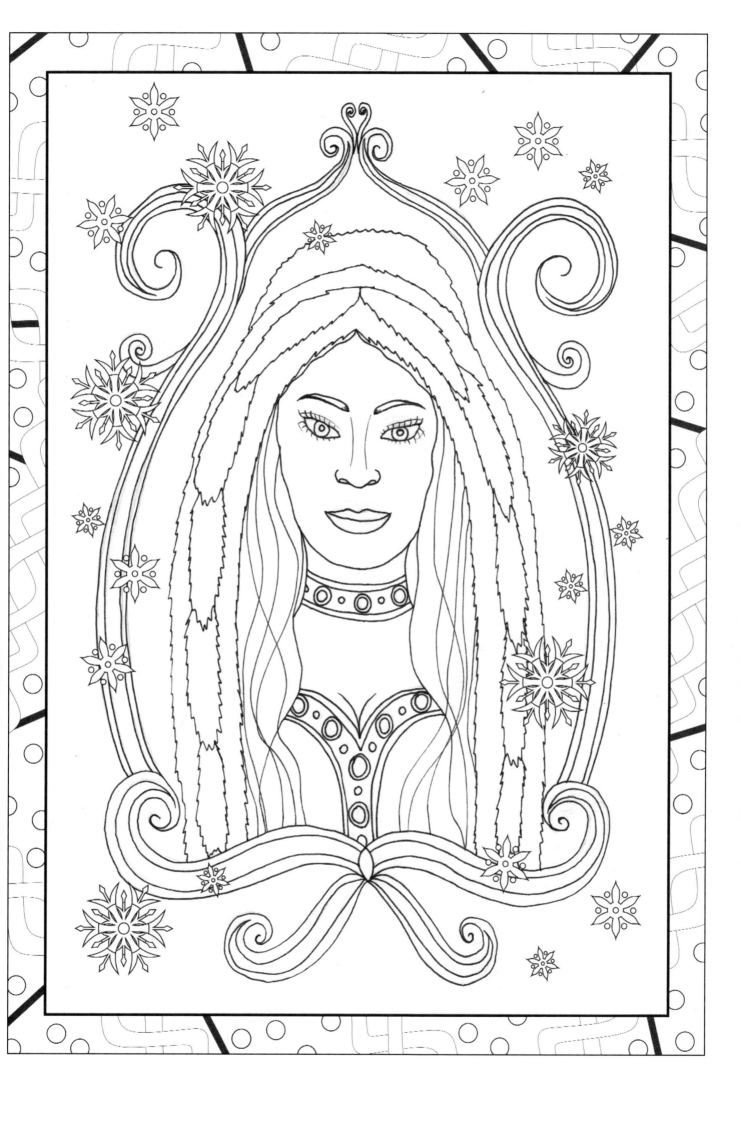

THOR

— Norse —

Thor is a warrior god who controls storms and oversees justice.
He is incredibly strong and wields his hammer Mjollnir which produces
thunder when struck and lightning when thrown.
Thor is often depicted as a huge red haired chap with a beard who
likes a drink and has a very hearty appetite.
He switches between full on belly laughter to uncontrollable rage.
Thor is a protector and guardian who rides a chariot drawn by two
goats: Tanngrisni and Tanngnost. The day Thursday is named after Thor.

God of thunder, and lightning he oversees
justice and punishes wrong doers
With mighty Mjollnir, his trusty hammer
He is strong and mighty although does love a good drink.
He is a protector and guardian and rides a goat drawn chariot
Enforcer of good, Thor

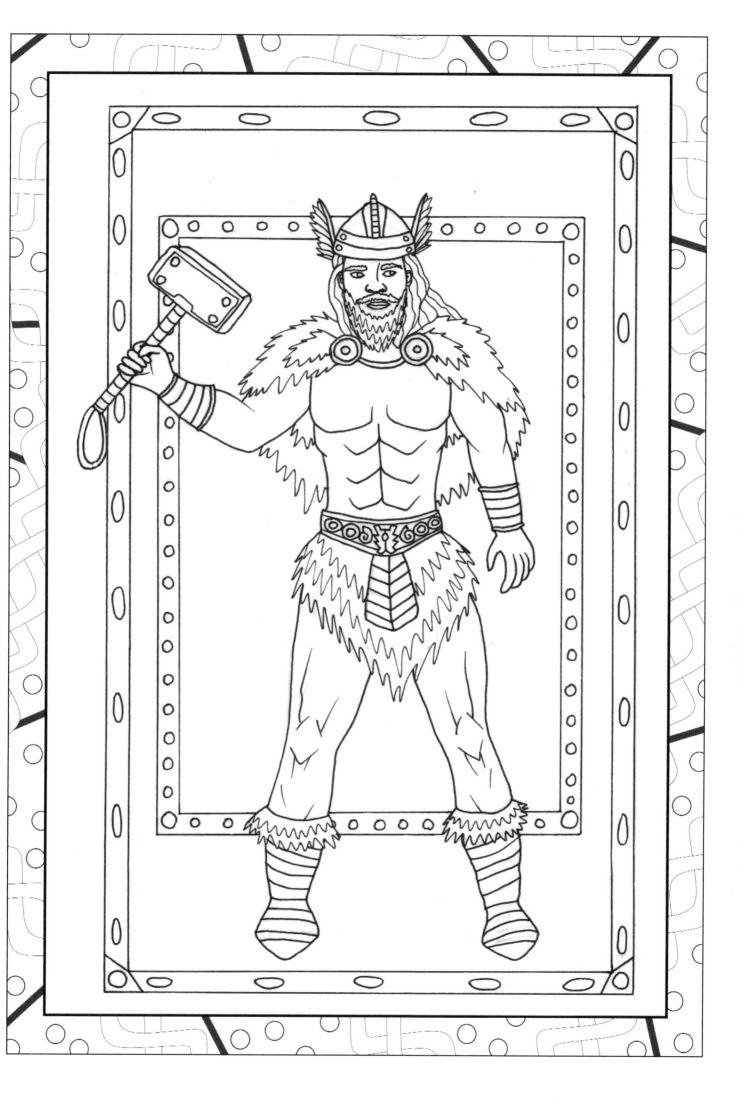

VALKYRIES

— Norse —

The Valkyries are female spirits who ride the winds, turning up on battlefields to collect the souls of the heroes and brave warriors from those that are slain to guide them to the halls of Valhalla. When not in battle they serve in Valhalla. Their name translates as 'choosers of the slain' suggesting that they don't just pick up the souls of the dead but actually decide and influence which ones die. Weaving the destiny of warriors they are said to use intestines for their thread, severed heads as weights and swords and arrows for beaters.

Riders of the wind, female spirits combing the battle fields, choosers of the slain

They guide valiant warriors to the halls of Valhalla

They decide and influence which heroes die

Weaving destinies, the futures of champions, servants of Freya

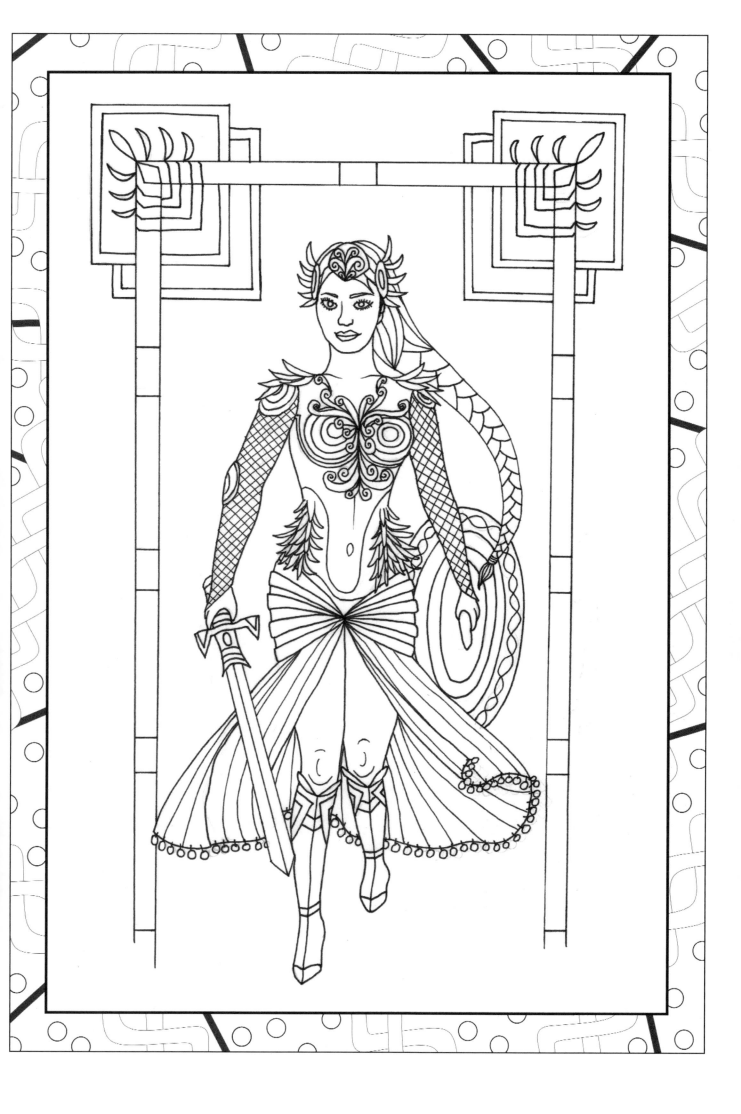

BARON SAMEDI

— Around the world —

Baron Samedi is a Loa of the dead and the head of the Ghede family of Loas,
the largest family of Loa in Vodou who embody the power of death and fertility.
He is loud, rude (swears a lot), sexual and definitely likes to party.
The Baron can be found at the crossroads between the worlds and
greets the souls of the dead as he leads them to the Underworld.
Usually depicted wearing a top hat, tuxedo and dark glasses he has a white
painted, often skull like, face. He has a particular liking for tobacco and rum.

It is me who carries coffins, abobo! Ah! It's really you?
Yes, it's me, abobo! I have power to stop singing
To prevent death from taking me away,
because if you kill me, it is a crime
Since it's the great king of Ife, where mortals
have never been, who gives us light.

"Yoruban Yanvalou, translated by Rigaud"
Abobo is a Haitian Creole expression of praise.

CH'ANG-O

— Around the world —

Ch'ang-O is a Chinese goddess of the moon. she and her husband were banished from heaven and forced to become mortal and live on earth. Seeking to return to her place in the skies she took a full shot of immortality potion (meant for both her and her husband).
She floated to the moon destined to spend eternity alone until her husband was made a sun god. having forgiven her they reconciled and do the eternal dance of the sun and the moon. During her festival in China petitions are sent to her by women to bring them their soul mate. She is offered sweet foods and incense and the hare is sacred to her.

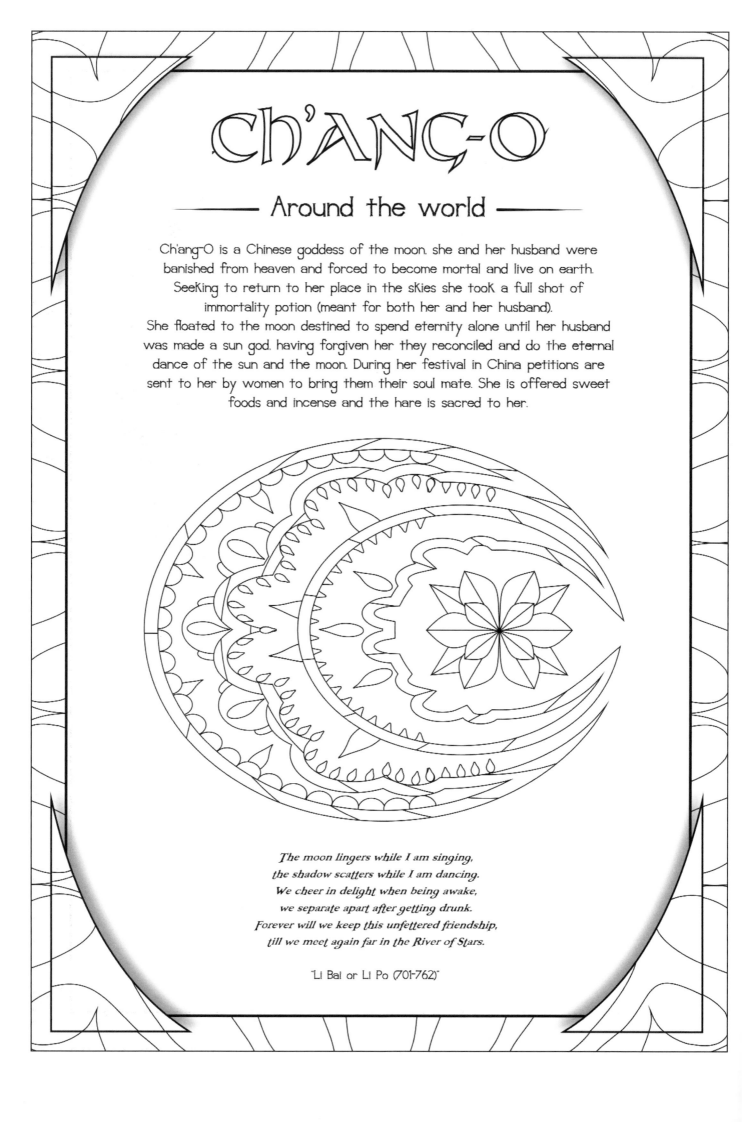

The moon lingers while I am singing,
the shadow scatters while I am dancing.
We cheer in delight when being awake,
we separate apart after getting drunk.
Forever will we keep this unfettered friendship,
till we meet again far in the River of Stars.

"Li Bai or Li Po (701-762)"

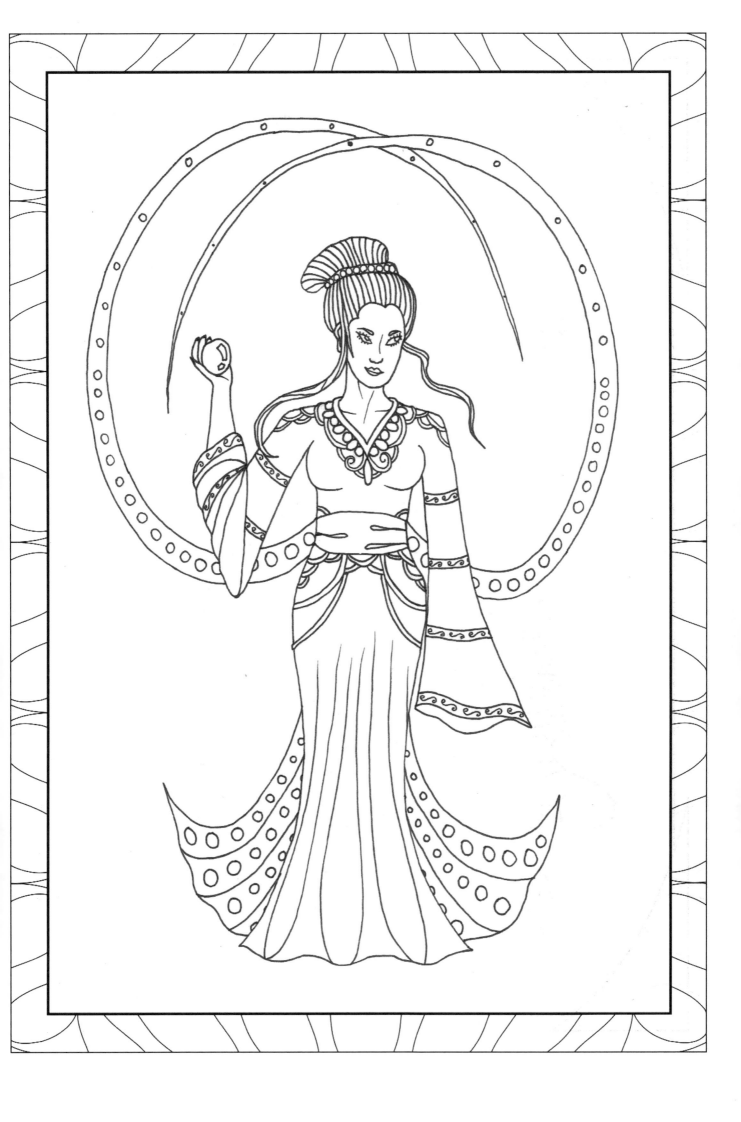

CORN MOTHER

— Around the world —

In Native American tradition there are many variations on the corn mother story.
CheroKee myth tells of Selu who was the first woman and goddess of the corn.
She was Killed by her twin sons who feared her power but with her
last dying words she taught them how to plant and farm corn so that
her spirit was resurrected with each harvest.
The Hopi tribe call her Qocha Mana but she is worshipped by nearly
all Native American tribes, most of the names translate as
Corn Mother, Corn Maiden or Corn Woman.
She is the goddess of th wisdom, magic and hunting.

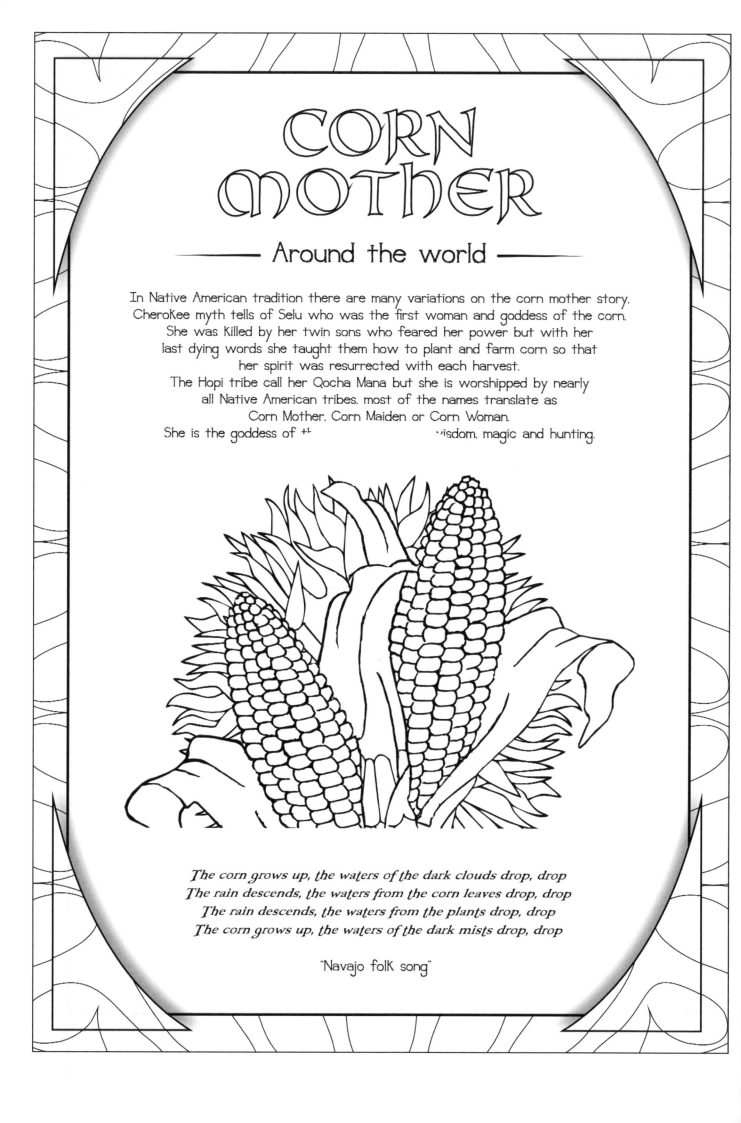

The corn grows up, the waters of the dark clouds drop, drop
The rain descends, the waters from the corn leaves drop, drop
The rain descends, the waters from the plants drop, drop
The corn grows up, the waters of the dark mists drop, drop

"Navajo folK song"

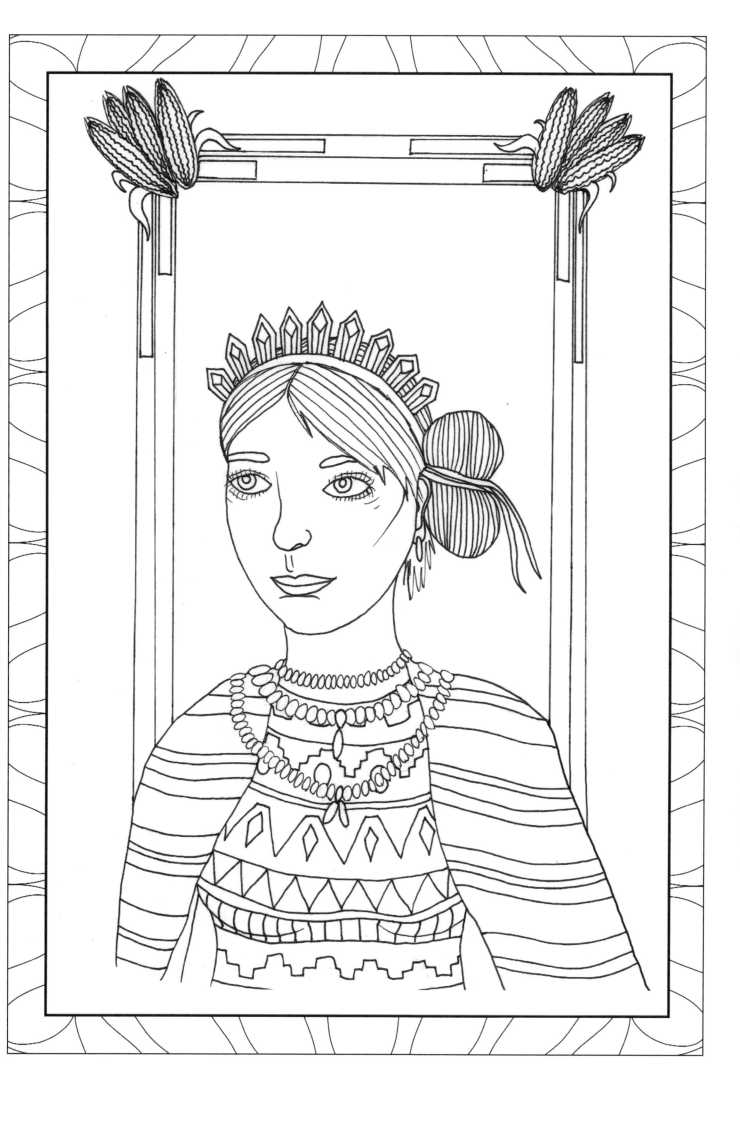

IXCHEL

— Around the world —

Ixchel is a Mayan moon, weaving, healing, childbirth and fertility goddess
who sent rain to feed the crops and created rainbows.
Her name translates as 'Lady Rainbow' and as a weaver goddess she sends
her whirling spindle to create the motion of the universe.
Often depicted in Mayan glyphs and carvings as sitting upon a sky-bar,
the figures drawn above or over the sky bar were deities or spirits of
the dead. She is also sometimes pictured carrying an upturned vessel
representing the gift of life giving water.
When she is in a good mood she blesses the earth with rain and when she
is in a bad mood she sends floods and hurricanes.

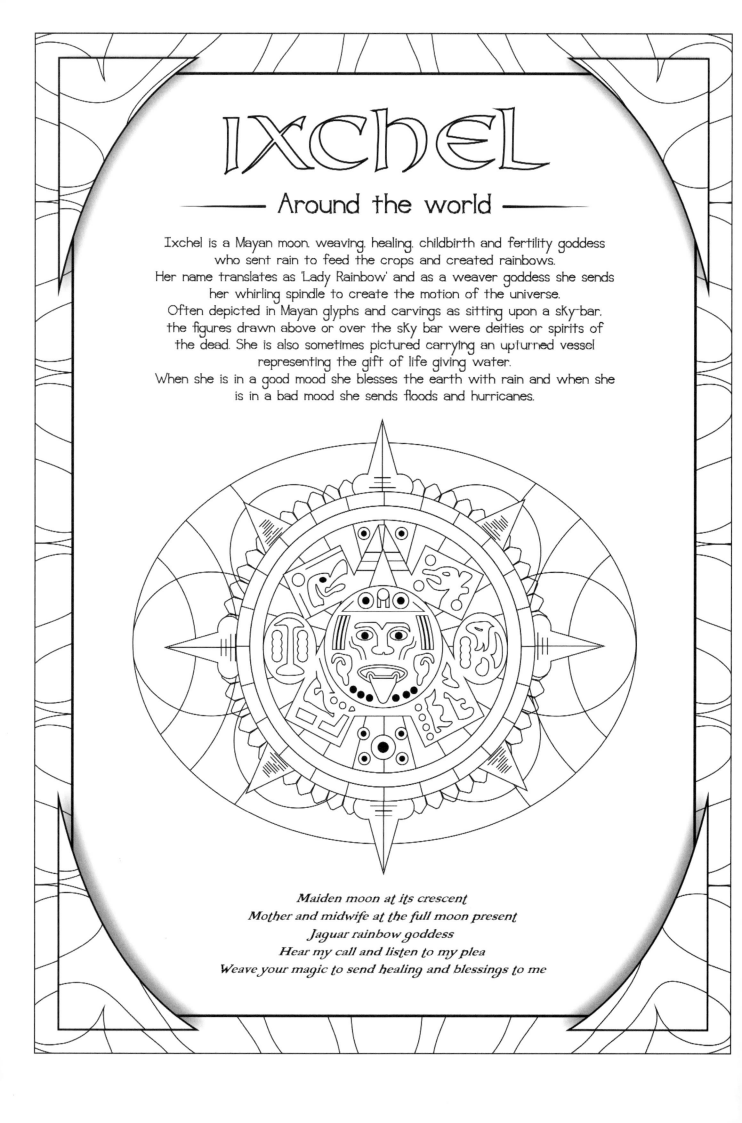

Maiden moon at its crescent
Mother and midwife at the full moon present
Jaguar rainbow goddess
Hear my call and listen to my plea
Weave your magic to send healing and blessings to me

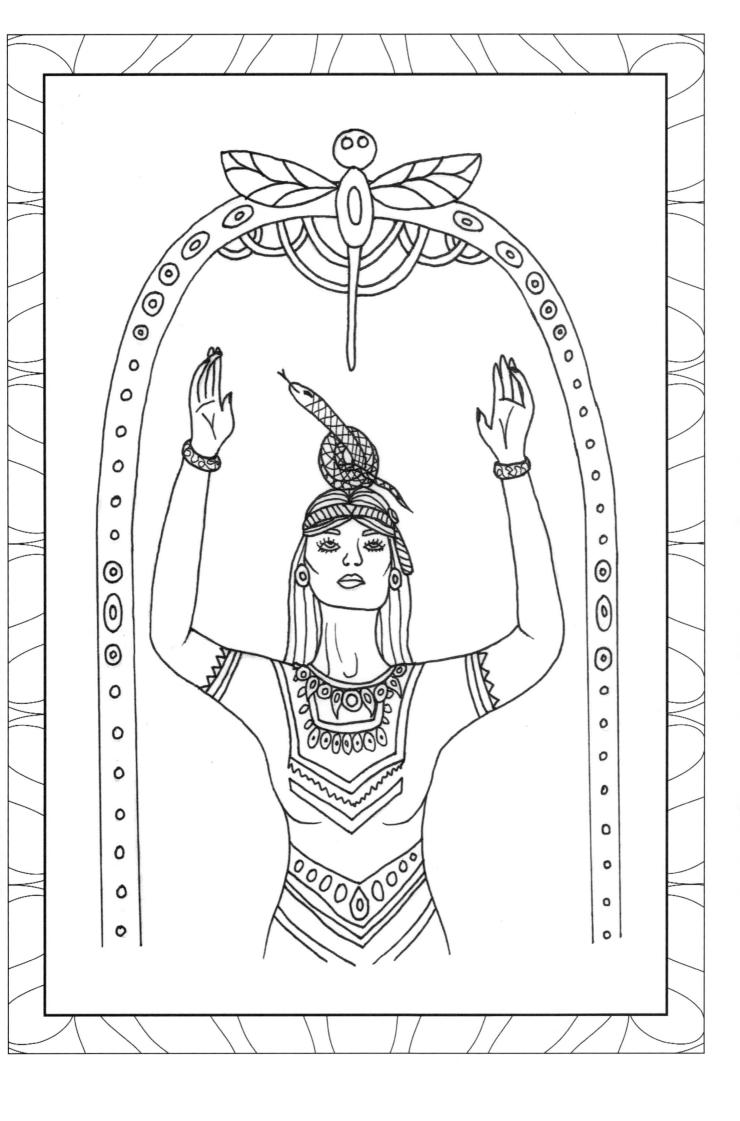

LILITH

— Around the world —

Lilith is often thought to be one of the first witches and can
be found in several different parts of the world by various
names from the Sumerians to the Greeks to the Babylonians.
She has been described as a night demon with a beautiful face and great
wings with talons for feet, said to steal babies from their cradles at night.
She appears in early versions of the Old Testament as the
first wife of Adam, created as his equal but cast aside
because she refused to do as she was told.
She is a goddess of freedom, courage, playfulness, passion, pleasure and sexuality.
Her symbols are apples, owls and snakes.

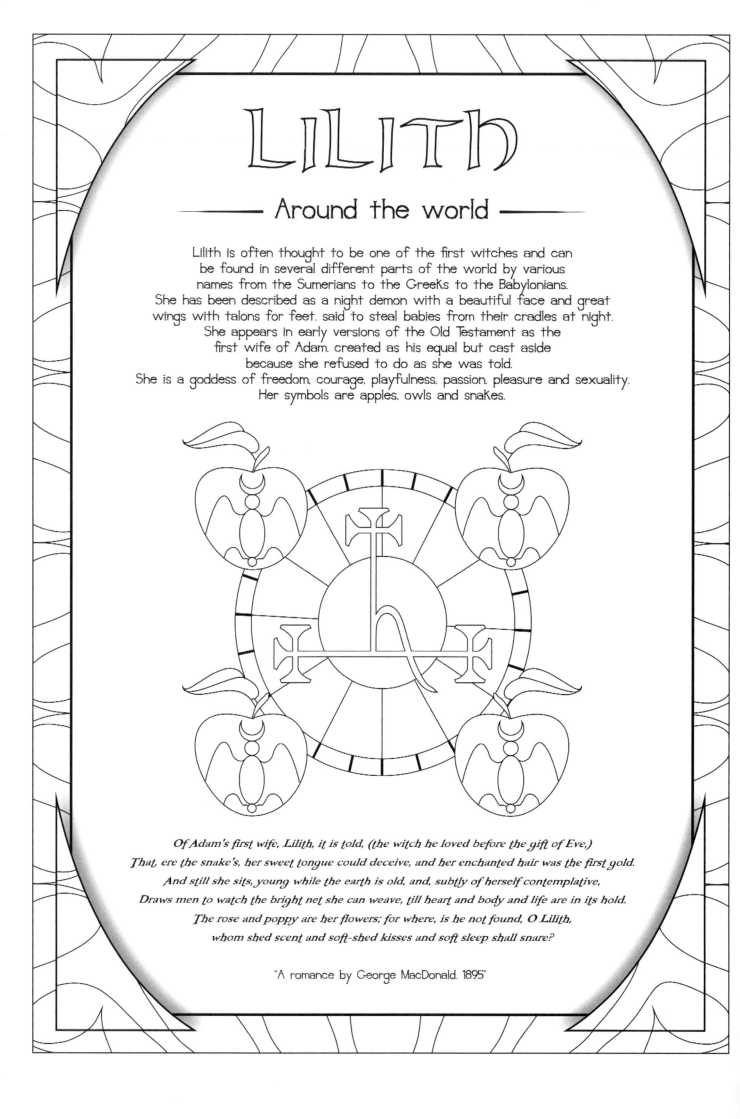

Of Adam's first wife, Lilith, it is told, (the witch he loved before the gift of Eve,)

That, ere the snake's, her sweet tongue could deceive, and her enchanted hair was the first gold.

And still she sits, young while the earth is old, and, subtly of herself contemplative,

Draws men to watch the bright net she can weave, till heart and body and life are in its hold.

The rose and poppy are her flowers; for where, is he not found, O Lilith,

whom shed scent and soft-shed kisses and soft sleep shall snare?

"A romance by George MacDonald, 1895"

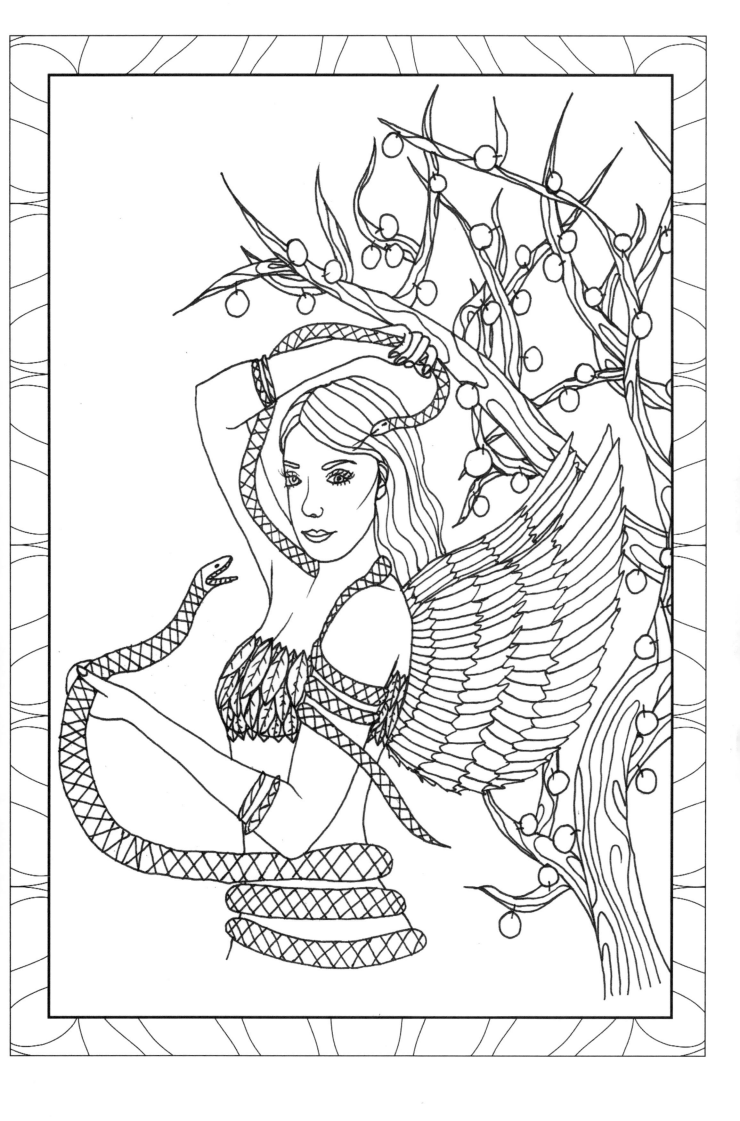

MAMAN BRIGITTE

— Around the world —

Wife of Baron Samedi. Maman Brigitte is a Loa of the dead. She is loud, sexual
and cusses a lot. She also definitely Knows how to have a good time.
Maman Brigitte liKes to drinK chilli infused rum and guards graveyards and
cemeteries. She is also called on for healing, lucK and justice.
Maman Brigitte is one of the few Loa who is white and is depicted
as being fair-haired and green-eyed with light European sKin.
Her animal is the blacK rooster and her colours are blacK and purple.

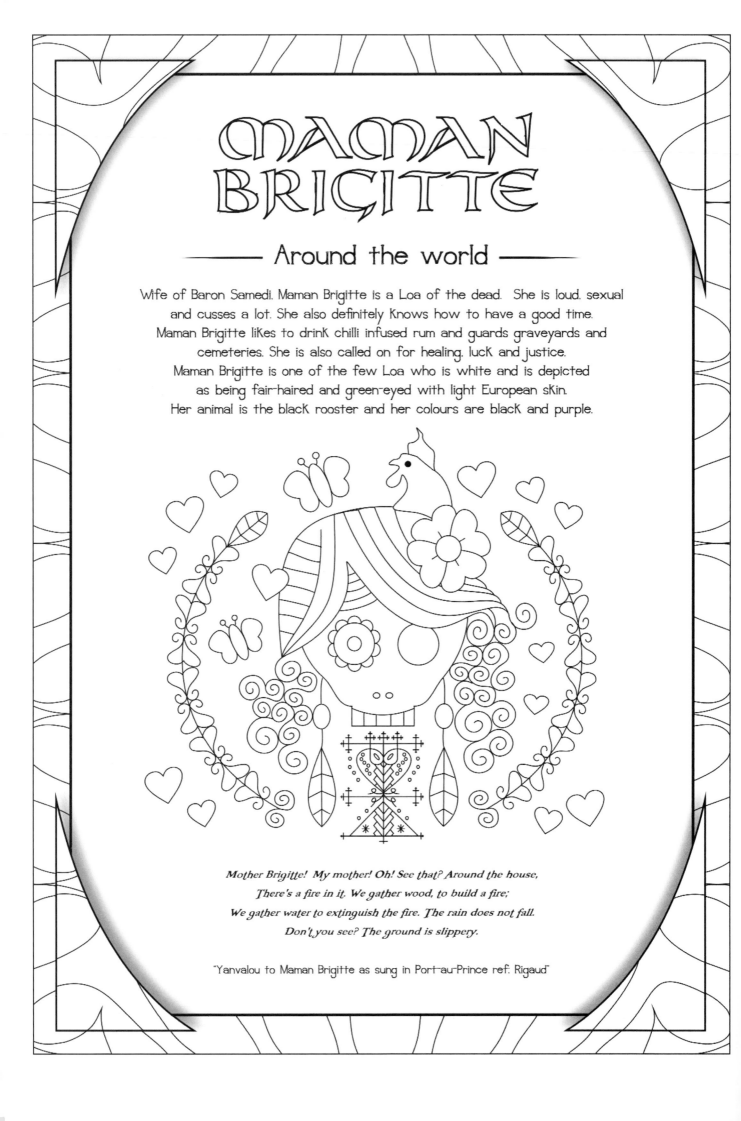

Mother Brigitte! My mother! Oh! See that? Around the house,
There's a fire in it. We gather wood, to build a fire;
We gather water to extinguish the fire. The rain does not fall.
Don't you see? The ground is slippery.

"Yanvalou to Maman Brigitte as sung in Port-au-Prince ref: Rigaud"

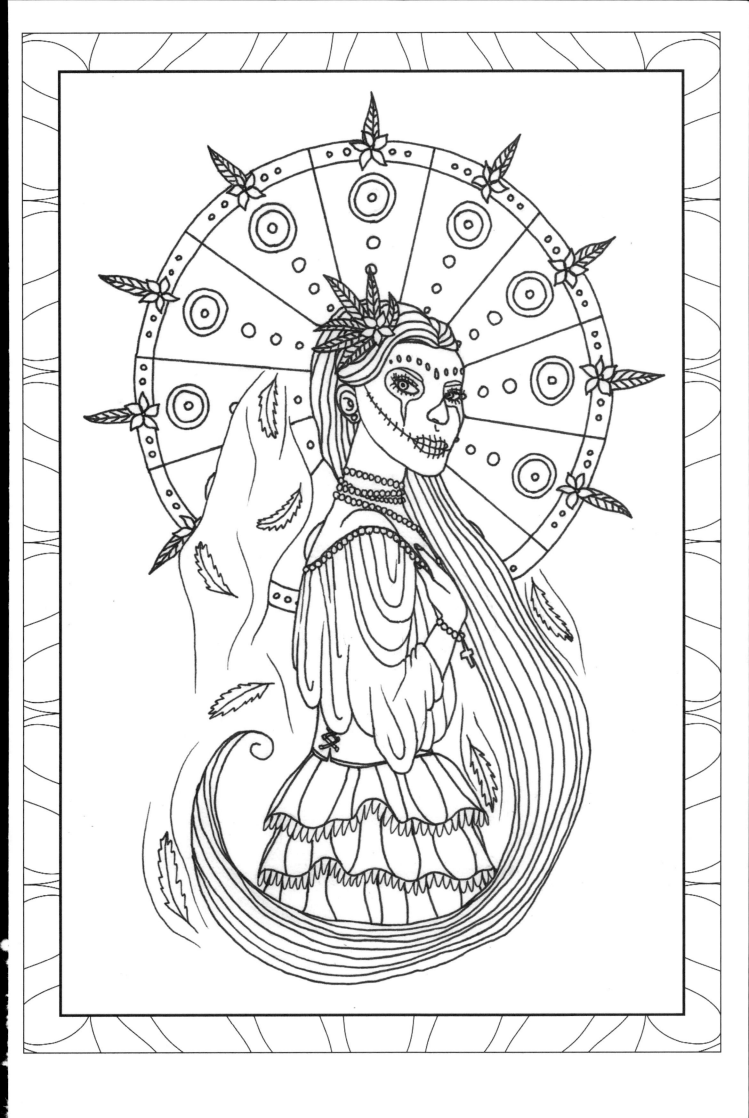

OSHUN

— Around the world —

Oshun is an Orisha who rules over love, beauty, wealth, maternity, diplomacy and marriage. She is known to be generous and kind but does have a very bad temper which she keeps a tight rein on most of the time but if it goes...destruction follows.
She is associated with the colour yellow, peacock feathers, mirrors, honey and anything beautiful. Oshun is the unseen mother present at every spiritual gathering and a bringer of harmony, she is the force of water and attraction and is believed to be both omnipresent and omnipotent.

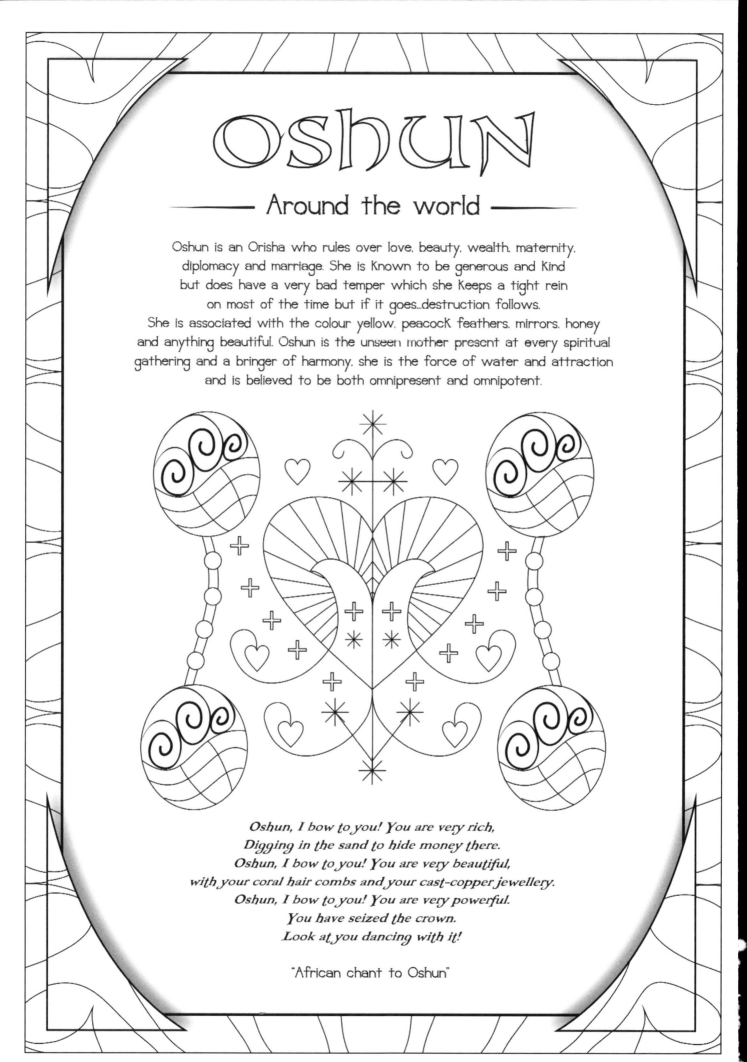

Oshun, I bow to you! You are very rich,
Digging in the sand to hide money there.
Oshun, I bow to you! You are very beautiful,
with your coral hair combs and your cast-copper jewellery.
Oshun, I bow to you! You are very powerful.
You have seized the crown.
Look at you dancing with it!

"African chant to Oshun"

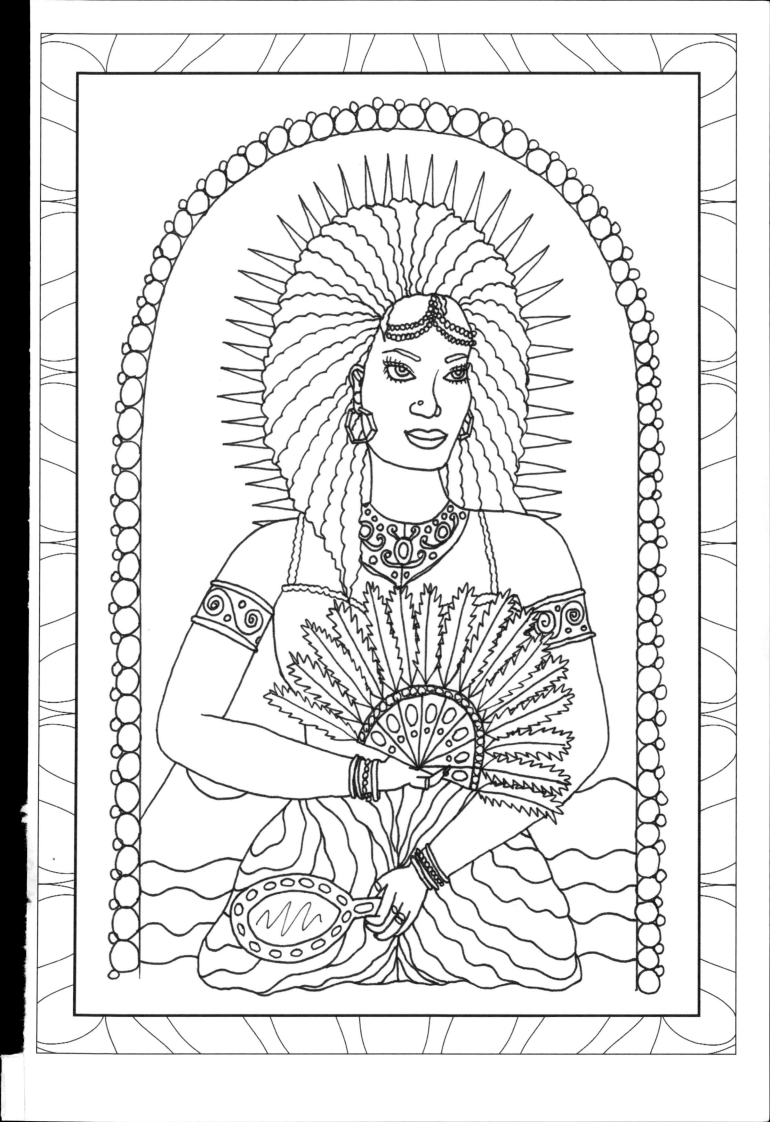

pele

— Around the world —

A Hawaiian volcano goddess named as 'she who shapes the sacred land'.
She is passionate, volatile and capricious.
She started life as a water goddess but her discovery of
fire took her in another direction completely.
Her volcanic lava causes destruction and upheaval
but also creates new life, land and change.
She brings a strong, fiery creative force with her that ushers in transformation.

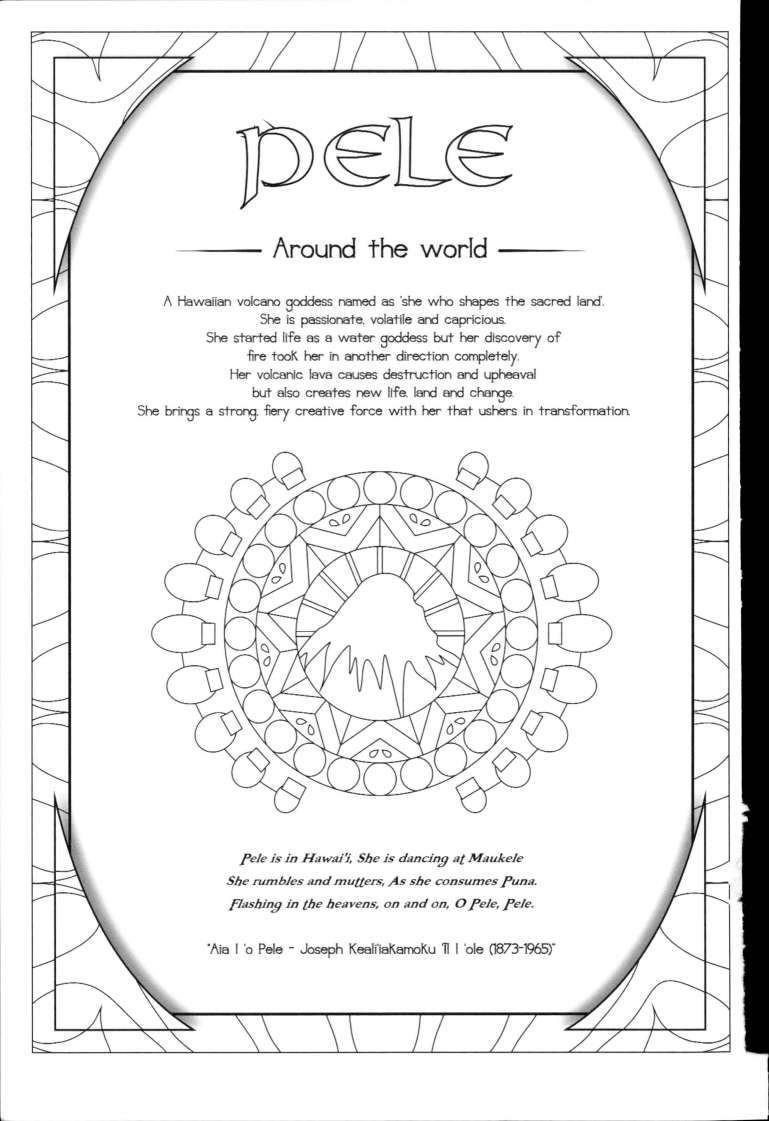

Pele is in Hawai'i, She is dancing at Maukele
She rumbles and mutters, As she consumes Puna.
Flashing in the heavens, on and on, O Pele, Pele.

"Aia I 'o Pele – Joseph Keali'iaKamoKu 'Iī I 'ole (1873-1965)"

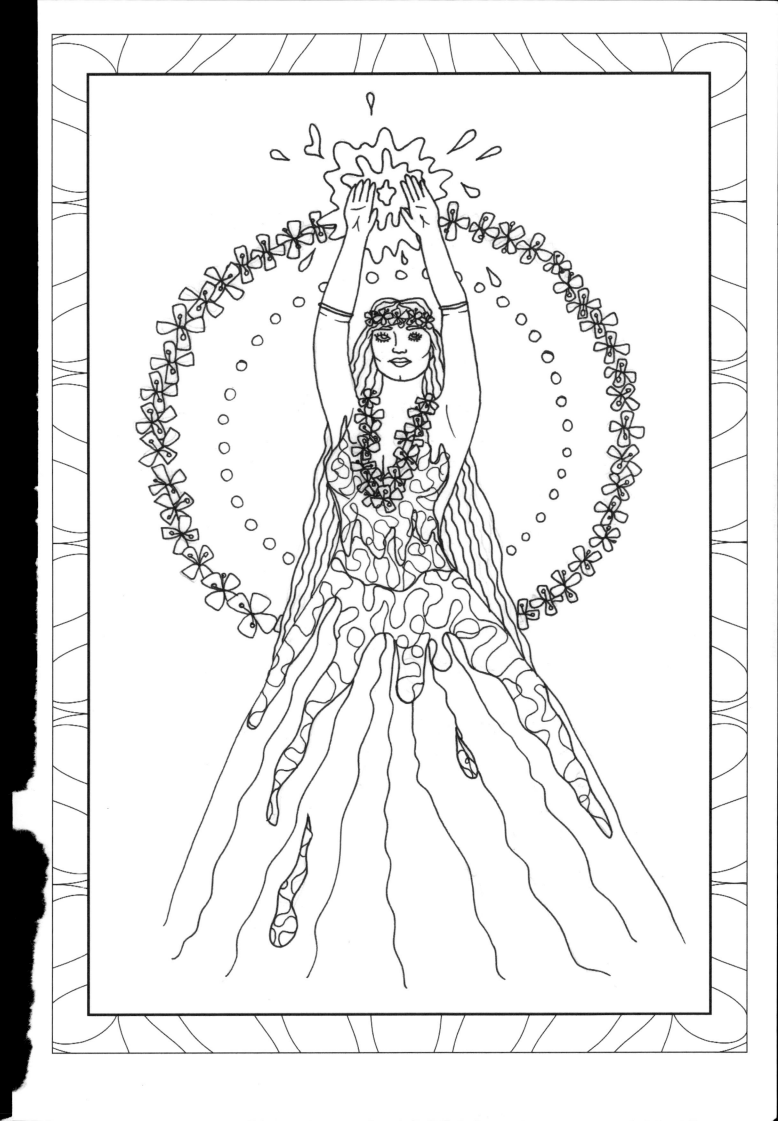

PAGANISM & SHAMANISM

What is Paganism? A religion, a spirituality, an alternative belief system, nature worship? You can find support for all these definitions (and many more) in dictionaries, encyclopaedias, and text books of religion, but subscribe to any one and the truth will evade you. Above all Paganism is a creative pursuit, an encounter with reality, an exploration of meaning and an expression of the soul. Druids, Heathens, Wiccans and others, all contribute their insights and literary riches to the Pagan tradition. Moon Books invites you to begin or to deepen your own encounter, right here, right now. If you have enjoyed this book, why not tell other readers by posting a review on your preferred book site.